IMAGES
of America

FANWOOD

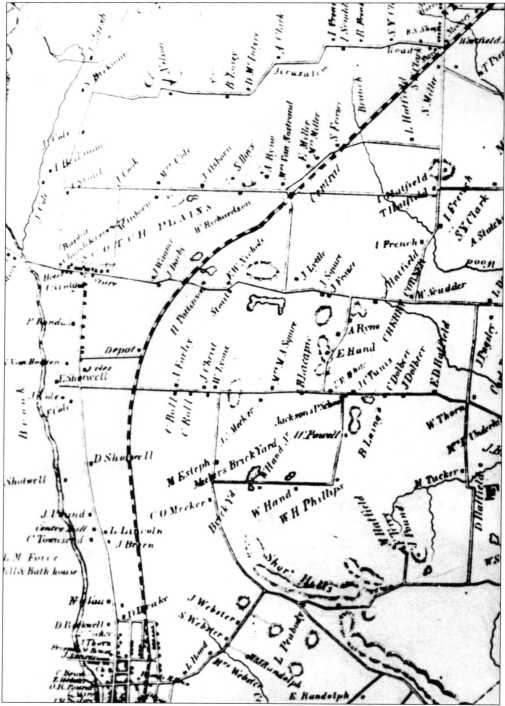

THE FIRST TRACKS. The Central Railroad of New Jersey was instrumental in the development of Fanwood. This 1850 map shows the early tracks that followed the course of the future Midway Avenue in the direction of Plainfield, seen at the bottom of the map.

2

IMAGES
of America
FANWOOD

Fanwood Historic
Preservation Commission

ARCADIA

Copyright © 2004 by the Fanwood Historic Preservation Commission
ISBN 0-7385-3590-7

First published 2004

Published by Arcadia Publishing,
Charleston SC, Chicago IL, Portsmouth NH, San Francisco CA

Printed in Great Britain

Library of Congress Catalog Card Number: 2004102490

For all general information, contact Arcadia Publishing:
Telephone 843-853-2070
Fax 843-853-0044
E-mail sales@arcadiapublishing.com
For customer service and orders:
Toll-free 1-888-313-2665

Visit us on the Internet at www.arcadiapublishing.com

RECOGNITION. The Fanwood Park Historic District has been listed on the New Jersey Register of Historic Places.

CONTENTS

ACKNOWLEDGMENTS

A major expression of appreciation for the content of this book goes to Howard Drewes, Robert S. Rau Jr., and Robert Rau Sr., and all others who assisted them in putting together the book published in 1990 to celebrate the 100th anniversary of the Fanwood Fire Department. *Fanwood Fire Company and Borough of Fanwood* provided half of the photographs and much of the information for this publication.

Others who have contributed photographs, information, and support are the following: Evie Andrews, Larry Andrews Sr., Charlotte Baker, Pat Bellone, Barbara and Bob Brennan, Bill Burke, Marianna Caldwell, Jackie Cecchetinni, Amy Cohen, Karin Dreixler, Alan Ebersole, George Germinder, John Grady, Joan Kirner, Marie Leppert, Helen Lindsey, June and Bob McCarthy, Eleanor McGovern, Kathy Mitchell, Kingsland Oakes, Michael Oakes, Kevin O'Brien, Joe Qutub, Peggy and Earl Phillips, Clayton Pierce, Jean Rosen, Sheldon Roskin, Gloria Rusnak, Dolores Schetelich, Joe and Nancy Schott, Charlie Smith, Kathleen Smyth, Joanne Sprague, Doris Terry, Jack Todd, Anne Vardy, Dan Weiss, George Weiss, Ruth Wohlgemuth, Helen M. Lewis Wistner, Judy Wussler, Nancy Zerbe, the Fanwood Presbyterian Church, the Fanwood Borough Council and mayor, the Fanwood Library and staff, the Scotch Plains Fanwood High School Alumnae Association, and the *Suburban News*.

The members of the Fanwood Historic Preservation Commission have compiled this book with the aid of all these people, as well as other supporters. Without them, the task would have been impossible. The commission includes chairperson Dolores O'Brien, John Celardo, Barbara Cox, Ed Groskinsky, architect Kevin Mason, secretary Margaret McIntyre, Joseph Nagy, Carol Oakes, and Craig Schaible.

INTRODUCTION

The borough of Fanwood is nestled in the center of the horseshoe-shaped township of Scotch Plains. Its modest size—just one square mile—belies its significance as a community. The borough owes much of its identity to the railroad, which sparked public works and road improvements and helped establish Fanwood as a separate borough more than 100 years ago.

The development of Fanwood can be traced to the early days of railroading in New Jersey—the beginning of freight and passenger transportation. In the first part of the 19th century, Col. John Stephens, the so-called "Father of American Railroads," believed that railroads would be an economical way to transport goods in the rapidly growing state. His ideas were at first met with derision, but when the Camden & Amboy Railroad was chartered in 1830, the means of moving products from the state's industrial centers to distant destinations was launched. Stephens's foresight was proven correct.

The transportation of passengers was also becoming important, and by 1838, work had begun on the Elizabethtown and Somerville line, which ran from Elizabeth, along Midway Avenue, into Plainfield. On January 1, 1839, the rail line opened with the New Year. Some 10 years later, the Central Railroad of New Jersey came into being.

In 1874, the rail line was rerouted, and the station was relocated from Midway Avenue and built on its present location near the corner of Martine and North Avenues. The Land Improvement Company, owned by the Central Railroad, had purchased 350 acres in the Fanwood Park area; it only made sense for the railroad to relocate to nurture population growth and promote passenger and freight business.

At this point, the rail line was a part of Fanwood Township, a large tract of land bordered by Green Brook and Robinson's Brook. In 1877, a rift occurred between the old village center of the township and the new center, where the railroad had been relocated. Residents of the railroad center felt that they were not being treated fairly by the governing body of the township. The seeds of a separate borough were sown when meetings were held in the Old Club House on South Avenue. Street lighting and road repairs were the issues, as well as the system for granting liquor licenses.

Ever so slowly, the borough of Fanwood separated from Fanwood Township. In 1887, the Independent Citizens Club was formed to protest the unequal division of tax burdens. A vote against town improvements in the borough led George Kyte and Thomas Young to propose the creation of an independent borough. It took a special act of the state legislature to start the

process of separation. In 1895, a vote was taken in Fanwood to decide the issue. The decision to establish the borough was finally firm, and Young served as mayor during the first four years of the tiny municipality's existence.

Fanwood was actively promoted as an ideal place to live because of the purity of its air and the beauty of its surroundings. The elegant residences built near the rail station set a tone that attracted new residents. Meanwhile, the population grew with the farming of open lands and, later, accelerated with the expansion of the lumber and coal industries. Developers created other businesses and residential areas.

These changes required roads, and George Kyte, known as the "Father of Fanwood," was instrumental in the late 1880s in providing, at no cost to taxpayers, crushed stone and slag to build roads in the town and around the freight house. Such service to the community was typical of this devoted public servant, who died in 1900 while holding the office of mayor.

At first, Fanwood expanded slowly. In 1895, there were just 350 residents. It was not until 1920 that the population doubled to more than 700. During the next decade, however, the population surged. By 1930, some 1,400 people were living in Fanwood. This growth was spurred by the large influx of Western Electric employees. The Western Electric plant was located in Kearny, and a direct train ran there from the Fanwood station. Two Western Electric employees established the Cooperative Realty Corporation of America, which later developed an area called Fanwood Terrace, located near the station.

Since then, the community has come a long, long way and now has more than 7,000 residents. Despite the enormous growth, much has remained the same in Fanwood. The railroad is still the central artery of daily life and the reason for the town's being. Nearly 900 commuters and other travelers board trains every day from the station. Businesses, schools, churches, and services of local government have expanded, but the community remains a peaceful and beautiful place for residents to raise their families.

To help perpetuate its history, the Fanwood Historic Preservation Commission has brought together photographs that illustrate the town, its railroad, and the people and places that have made it the vibrant and caring community that it is today.

(The contents of this introduction have been drawn from information in *Fanwood Fire Company and Borough of Fanwood,* published in 1990.)

One

THE ENGINE
ROUNDS THE BEND

The wail of the locomotive has been heard in Fanwood for more than 150 years. From the primitive horse-drawn train used in Elizabeth in 1836 to the modern trains that now transport as many as 850 passengers per day, railroad travel has undergone dramatic change. Fanwood's first station, on Midway Avenue, gave birth to a community with a railroad as its nucleus. When the borough broke from the larger township in 1895, the railroad secured itself as the *raison d'être* for the town. The Central Railroad of New Jersey was the beginning of this tiny community, and many photographs depict this heart of Fanwood.

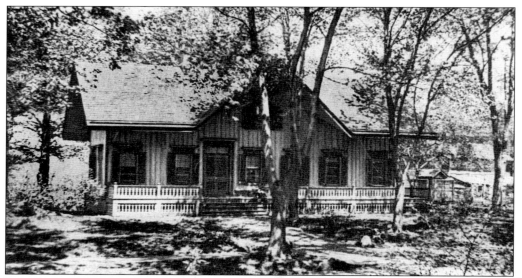

THE FIRST RAILROAD STATION. In 1839, 50 years before Fanwood became a borough, the Elizabethtown & Somerville Railroad established a route westward from Elizabethport to Plainfield. The tracks ran along what is today Midway Avenue. At the intersection of Midway, Woodland, and Martine Avenues, this passenger station was built to provide service to residents of the nearby village of Scotch Plains.

CENTRAL RAILROAD OF NEW JERSEY.

TIME TABLE. H

To take effect on MONDAY, NOVEMBER 22nd, 1854.

| TRAINS GOING WEST. | | | | | | TRAINS GOING EAST. | | | | |
| NEW YORK TO PHILLIPSBURG. | | | | | | PHILLIPSBURG TO NEW YORK. | | | | |
STATION.	Passenger Train. No. 1.	Pass. & Fr't Train. No. 3.	Passenger Train. No. 5.	Passenger Train. No. 7.	Freight Train. No. 9.	STATION.	Passenger Train. No. 2.	Passenger Train. No. 4.	Pass. & Fr't Train. No. 6.	Passenger Train. No. 8.	Freight Train. No. 10.
New York,	8.00 A. M.	1.00 M.	4.00 P. M.	5.00 P. M.		Phillipsburg,		6.15 A. M.	9.20 A. M.	3.00 P. M.	1.45 P. M.
Elizabethport,	8.55 "	1.55 P. M.	4.55 "	5.50 P. M.	4.30 A. M.	Springtown,		6.25 "	9.35 "	3.10 "	2.10 "
Elizabethtown,	9.07 "	2.05 "	5.05 "	6.00 "	4.45 "	Bloomsbury,		6.30 "	9.45 "	3.15 "	2.30 "
Craneville,	9.18 "	2.23 "	5.15 "	6.10 "	5.05 "	Bethlehem,		6.37 "	9.52 "	3.21 "	2.45 "
Westfield,	9.25 "	2.30 "	5.25 "	6.15 "	5.20 "	Asbury,		6.45 "	10.00 "	3.27 "	3.00 "
Scotch Plains,	9.32 "	2.38 "	5.33 "	6.20 "	5.35 "	N. Hampton,		6.55 "	10.15 "	3.35 "	3.25 "
Plainfield,	9.45 "	2.50 "	5.45 "	6.35 "	6.10 "	Clarksville,		7.00 "	10.20 "	*3.40 "	*3.40 "
New Market,	9.50 "	2.56 "	5.50 "	6.40 "	6.55 "	Clinton,		7.20 "	10.40 "	4.00 "	4.10 "
Bound Brook,	10.00 "	3.07 "	6.00 "	6.50 "	7.20 "	Lebanon,		7.25 "	10.47 "	4.05 "	4.23 "
Somerville,	10.12 "	3.18 "	6.15 "	7.05 "	8.00 "	White House,		7.35 "	11.05 "	4.15 "	4.50 "
Raritan,	10.15 "	3.23 "	6.20 "		8.10 "	North Branch,		7.45 "	11.15 "	4.25 "	5.20 "
North Branch,	10.22 "	3.30 "	6.30 "		8.30 "	Raritan,		7.55 "	11.24 "	4.32 "	5.50 "
White House,	10.37 "	3.45 "	6.40 "		8.53 "	Somerville,	6.35 A. M.	8.00 "	11.37 "	4.35 "	6.15 "
Lebanon,	10.47 "	4.05 "	6.50 "		9.12 "	Bound Brook,	6.45 "	8.10 "	11.48 "	4.45 "	6.50 "
Clinton,	11.00 "	4.10 "	6.58 "		9.30 "	New Market,	6.55 "	8.20 "	12.00 "	4.55 "	7.10 "
Clarksville,	11.15 "	4.30 "	7.15 "		9.50 "	Plainfield,	7.05 "	8.28 "	12.12 P. M.	5.07 "	7.35 "
N. Hampton,	11.20 "	4.35 "	7.20 "		10.15 "	Scotch Plains,	7.18 "	8.38 "	12.25 "	5.15 "	8.05 "
Asbury,	11.27 "	4.43 "	7.25 "		10.30 "	Westfield,	7.25 "	8.45 "	12.35 "	5.25 "	8.25 "
Bethlehem,	11.32 "	4.50 "	7.30 "		10.40 "	Craneville,	7.30 "	8.50 "	12.40 "	5.35 "	8.35 "
Bloomsbury,	11.40 "	4.57 "	7.38 "		10.55 "	Elizabethtown,	7.45 "	9.07 "	1.00 "	5.45 "	9.10 "
Springtown,	11.45 "	5.05 "	7.45 "		11.20 "	Elizabethport,	8.00 "	9.45 "	1.15 "	6.00 "	
Phillipsburg,	12.00 M.	5.20 "	8.00 "		11.40 "	New York,	9.00 "	10.45 "	2.10 "		

ELIZABETHPORT AND NEW YORK FERRY BOATS

WILL RUN AS FOLLOWS:

Leave Elizabethport at 8 & 9.45 A. M., and 1.15 & 3.30 P. M.
" New York at 8 & 10.40 A. M., and 1 & 4 P. M.

Printed at the office of the Elizabeth Gazetteer, Elizabethtown, N.J.

AN 1854 SCHEDULE. This timetable of the Central Railroad of New Jersey, the successor to the Elizabethtown & Somerville Railroad, shows five daily arrivals and departures from the station called Scotch Plains. The travel time from the station to New York City, which included a 55-minute ride from Elizabethport to Manhattan, was one hour and 32 minutes.

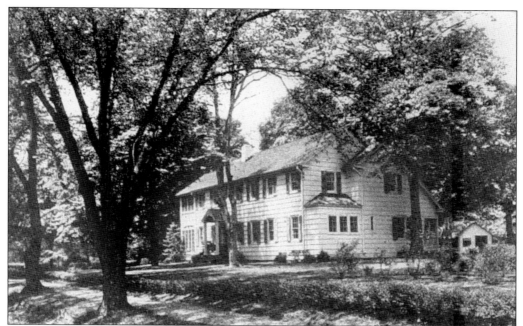

AN OLD STATION TO A RESIDENCE. When the Central Railroad of New Jersey abandoned the Midway Avenue route in 1874, the railroad station became a private residence, seen here in the 1920s after extensive renovations. The house is on Fanwood's local registry of historic structures.

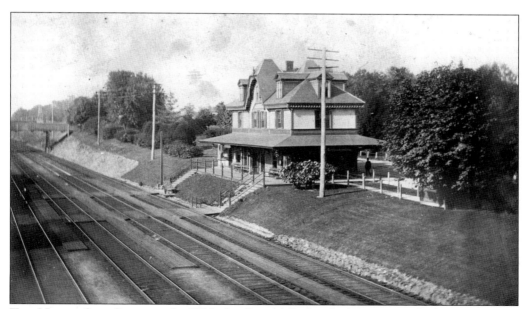

THE NORTH-SIDE STATION. In 1874, the Central Railroad of New Jersey built its station on its new route near Martine and North Avenues on the westbound side of the tracks. This photograph, taken in the mid-1880s, shows no pedestrian overpass but does show two sets of track-level walkways that cross the east- and westbound tracks. The Sheelen's Crossing Bridge can be seen west of the station.

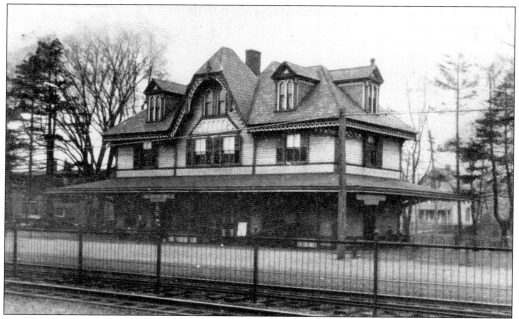

THE SISTER STATION. The Fanwood station was one of seven stations built by the Central Railroad of New Jersey in the late 1880s. This sister station was located on Clinton Avenue in Plainfield and was later demolished.

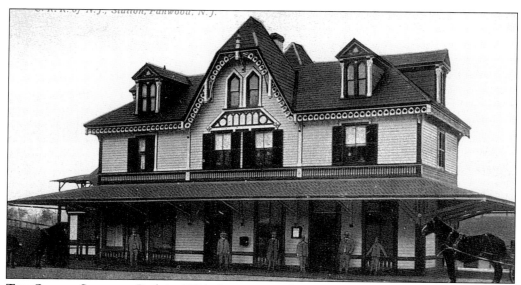

THE OLDEST STATION. Built in 1874, this structure functioned as a railroad station until 1965, when it became a community center for the borough. It is the oldest remaining railroad station in Union County. An excellent example of Victorian Gothic architecture, it is designated on the local and state historic registries and the National Register of Historic Places.

AN 1895 SCHEDULE. A short seven-minute train ride to Plainfield connected Fanwood residents to trains going to Philadelphia, Trenton, Baltimore, and Washington, D.C.

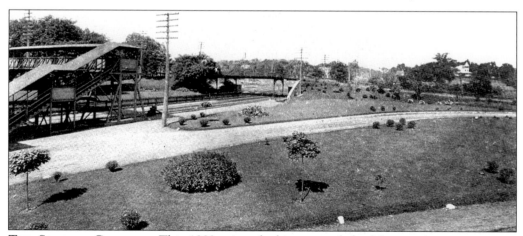

THE STATION GROUNDS. This 1880s view, looking toward the Martine Avenue overpass, shows the parklike character of the south side area. Because this predates the era of the automobile, no parking places are provided. The Martine Avenue overpass can be seen, as well as the first pedestrian overpass. About 300 residents lived in Fanwood at this time, which explains the presence of few residential structures.

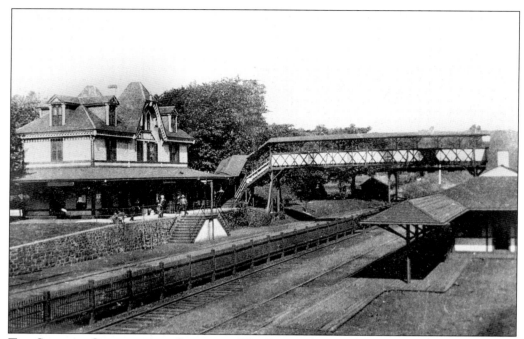

THE STATION COMPLEX AND OVERPASS. The Fanwood station complex *c.* 1900 consisted of the main station house on the westbound tracks, a pedestrian overpass to provide safe passage between the westbound and eastbound tracks, a small shelter for eastbound passengers, and a freight station, not shown.

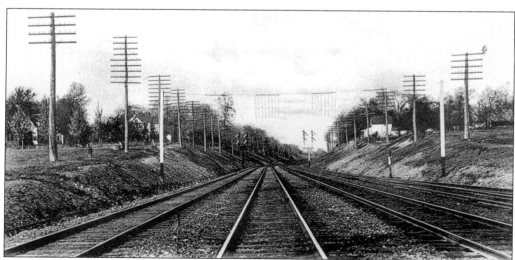

LOOKING EAST. In 1909, the depth of the Fanwood cut is brought into sharp relief by the absence of trees in this eastward view from Martine Avenue. The four tracks served commuter, freight, and long-distance passenger trains. The telegraph lines provided the communication system for the railroad. Today, only two tracks are in place for use by commuter trains.

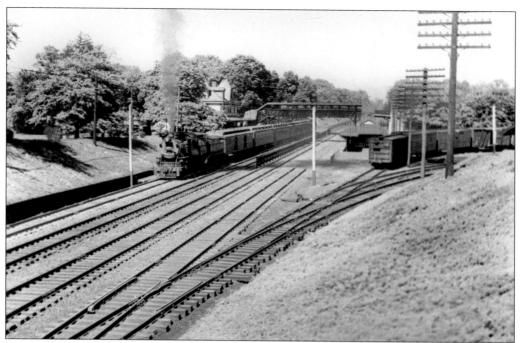

AN ENGINE AND SIDINGS. This westbound passenger train pauses at the Fanwood station to discharge and pick up passengers. The coal-burning steam engine spews a plume of smoke, which rises directly skyward.

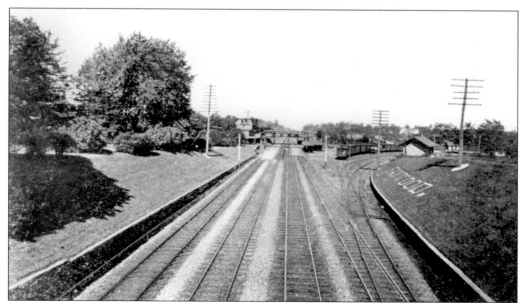

THE 1930s STATION. This eastward view from the Sheelen's Crossing Bridge reveals the north-side Fanwood station grounds, the south-side track sidings, the freight station, and a sloping bank with letters spelling "Fanwood."

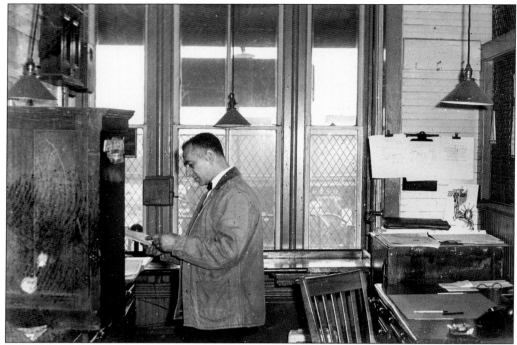

THE TICKET AGENT. Mike Ruschetta is at work in the ticket office in the early 1950s. By that time, the telephone had long since replaced the telegraph as the Central Railroad's principle means of communication.

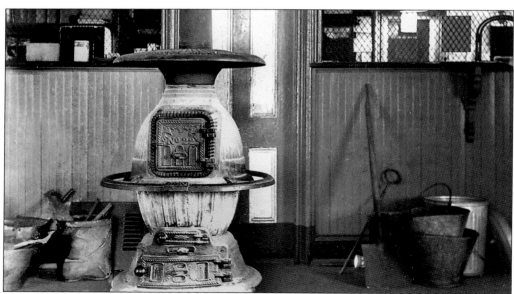

STAYING WARM. The potbelly stove provided heat for passengers in the main station waiting room. The metal scuttle for the coal supply, buckets for the coal ashes, and a poker are nearby. The two original potbelly stoves are preserved and housed in the historic railroad station, which now serves Fanwood as a community meeting room and a studio for municipal TV Channel 35.

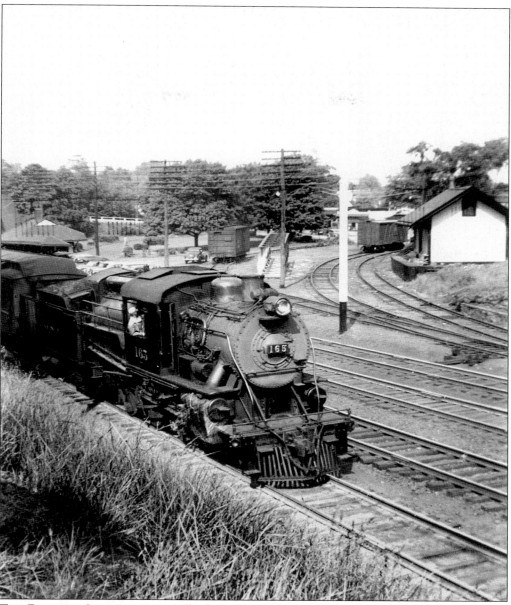

THE RAILWAY SETTING. A camelback engine at the head of a passenger train pauses in the westbound lane at the Fanwood station. Three railroad sidings can be seen in this 1940s photograph. The siding at the far right served the white freight station. The left two sidings, each hosting a freight car, ran across South Avenue to bring bulk materials into the coal and lumber yards.

SHEELEN'S CROSSING. A wooden truss bridge at Sheelen's Crossing provided access from North to South Avenues over the track bed. This bridge was called Central Crossing before being replaced in 1966 by the current concrete structure.

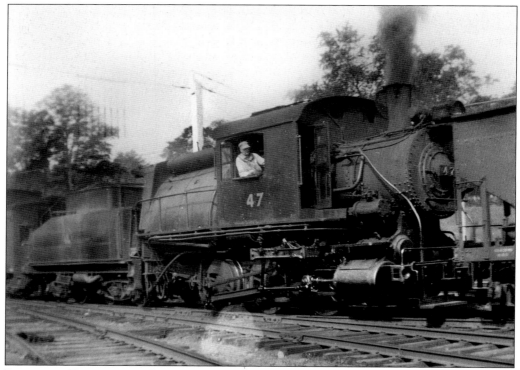

RAILROAD VIEWS. A small engine, known as a shunting engine, moved railroad cars to and from the sidings onto the mainline tracks.

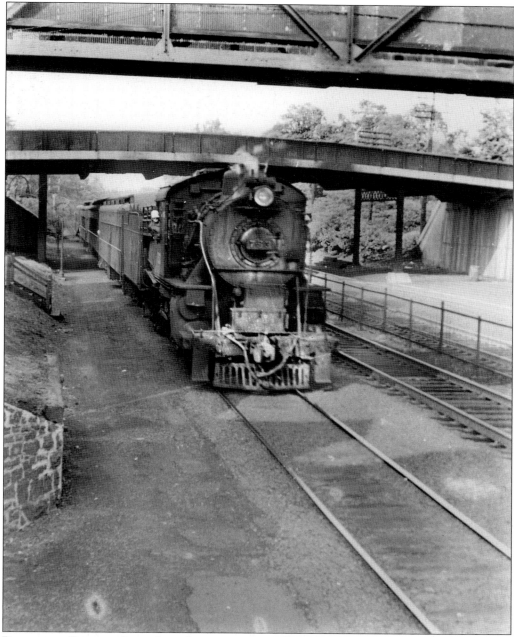

PLAINFIELD BOUND. A westbound steam engine pulling a passenger train enters the Fanwood station under the Martine Avenue bridge and the pedestrian overpass.

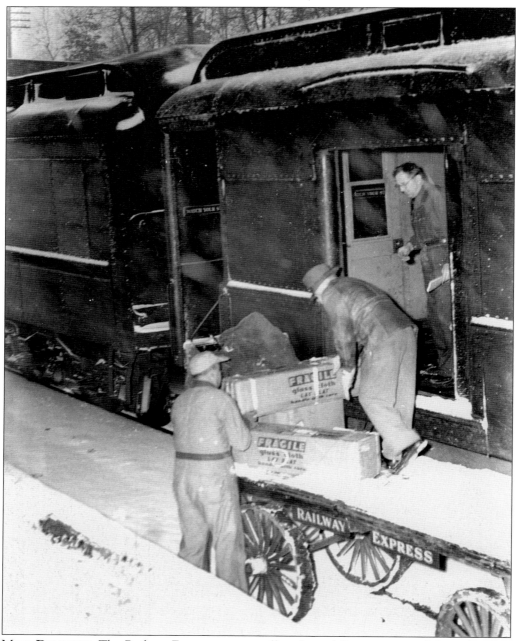

MAIL DELIVERY. The Railway Express was a small-package delivery service of the railroad in the 1950s. The station complex was a focus of commerce in the community. Mail was also hauled in bulk by rail at that time.

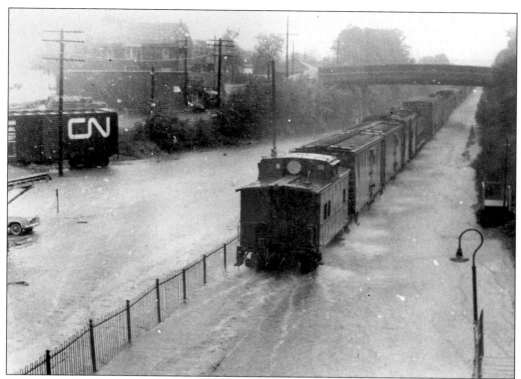

FLOODING. The trailing caboose of a freight train is seen in the 1960s as it heads westward under the Sheelen's Crossing Bridge on tracks covered by rampaging flood waters. Note the original bishop's crook lamp at the right, later replicated throughout the community.

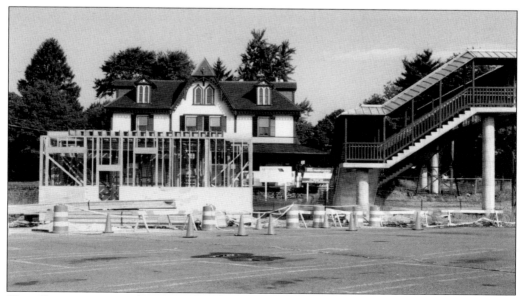

NEW CONSTRUCTION. A new steel-and-concrete pedestrian overpass spans the roadbed as the framework of a new south-side station rises in this 1989 photograph.

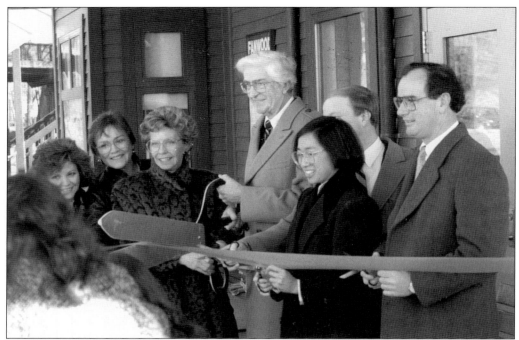

AN OFFICIAL WELCOME. In December 1989, a ribbon-cutting ceremony opened the doors to the new station. Pictured here, from left to right, are Councilwoman Linda Stender, Councilwoman Maryanne Connelly, Mayor Patricia Kuran, New Jersey Transit official Victor Strom, Assemblyman Bob Franks, New Jersey Transit director Eva Lerner-Larn, and Sen. Donald DiFrancesco.

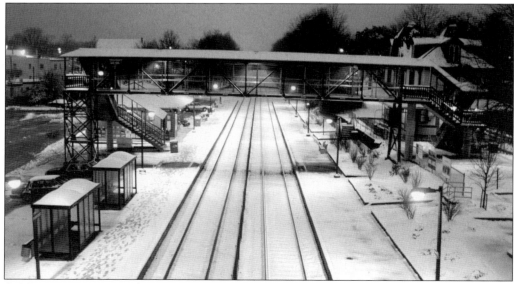

A NIGHTTIME VIEW. This is a 1990s winter view of the Fanwood station from the Martine Avenue Bridge. The old station has been retired from railroad duty; a south-side facility built in the 1980s has now assumed the role.

Two

A Stroll
Around Town

If you were to take a walk through Fanwood, you would catch a glimpse of many of the first dwellings built in the town, including four early farmhouses, several Victorian beauties, stately Colonial Revivals, angular Craftsman homes, a street of cottages built to house some of the first railroad workers, and a neighborhood of homes built for Western Electric commuters. Some of the great homes of the past have been demolished, but photographs preserve their place in history. These early houses were the heartbeat of this residential community created by the railroad.

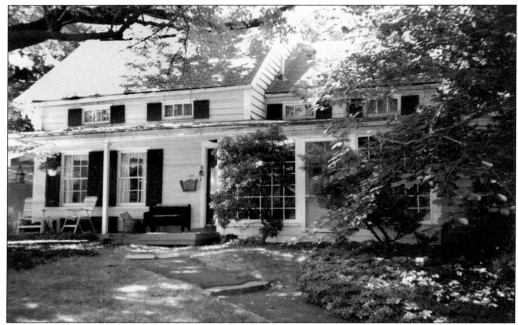

THE LAMBERTSON FARMHOUSE. Tucked away, 200 feet from the main street of Fanwood, is this early farmhouse. Portions of the farm predate the railroad and may go back to 1760. Tobacco and flax were the chief crops grown here in the 19th century. A windmill stood to the right of the driveway, supplying water to the house, the barn (now a house on MacLellan Place), and Fanwood's first fire hydrant.

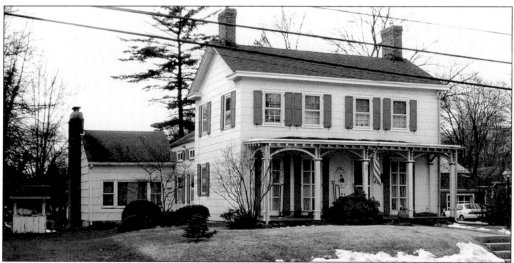

THE OSBORNE HOUSE. Isaac Halsey sold his estate in 1790 to John Baldwin Osborne, who operated a cider mill there. Patience Clark, Osborne's daughter, inherited the farmhouse and outbuildings, along with 25 acres, in 1848. She made numerous additions to the structure, her home until her death in 1857. Many of the original features have been preserved, including pine flooring, hardware, several three-board pine doors, and original glass panes.

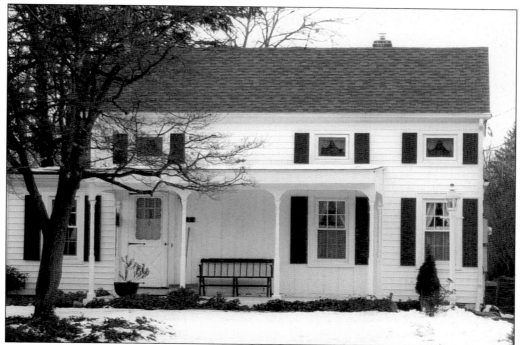

THE DARBY-HETFIELD HOUSE. This simple Colonial farmhouse dates back to 1830. It was built by Hannah Darby and, in 1902, was purchased by Sarah Hetfield. Hetfield was from a prominent family with roots going back to the Revolutionary War. In 1937, Ruth and Art Mayer purchased the house at a tax sale for $265; the lawyer's fee for the transaction was only $5. Fortunately, the house was restored and enlarged by the Mayers.

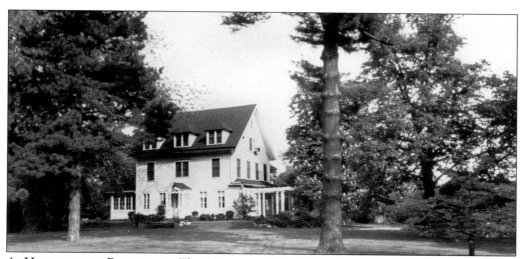

A HOTEL TO A RESIDENCE. The Homestead Hotel developed from a pre-Revolutionary farmhouse into a resort for city dwellers. Originally named the Russell House, the Homestead was purchased in 1890 by the Boucher siblings and was converted to this residential dwelling. Clarence Slocum bought it in 1931 and sold it to the borough in 1974. Unsuitable as a borough hall, it was razed in 1978 to make way for the current borough offices.

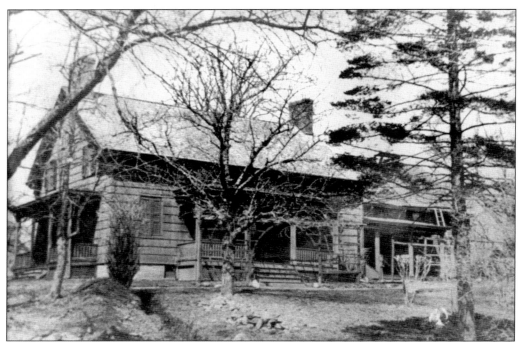

A Mansion's Beginnings. It is hard to believe that this simple frame farmhouse, erected in 1774, eventually became the elegant J. H. Martine home. Note that the lines of the original house correspond to the basic structure in the front façade of the house in the photograph below.

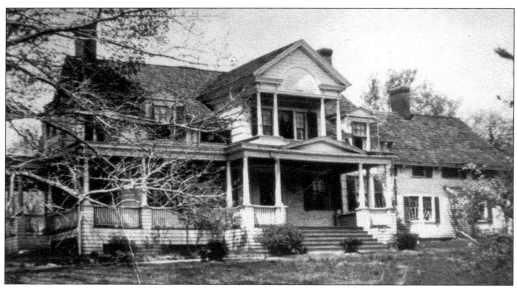

The J. H. Martine House. The old frame farmhouse became this stately mansion, seen here in 1910. The Gordon Urner family purchased it from the Martine family. The gabled dormer was added *c.* 1900, along with the welcoming portico and porch. Tapered columns provided graceful support. Gen. George Washington may have used this dwelling as his headquarters. The house was demolished in the 1930s.

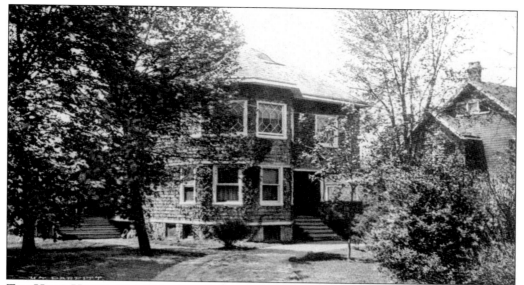

THE HOAR HOUSE. This Shingle-style house was home to W. H. Hoar, Fanwood's mayor from 1912 to 1917. Built in 1890, it bears several distinctive features. Eyebrow attic windows peek down on Fanwood's main thoroughfare, while the diamond-pane windows on the second floor give this Martine Avenue house a unique façade.

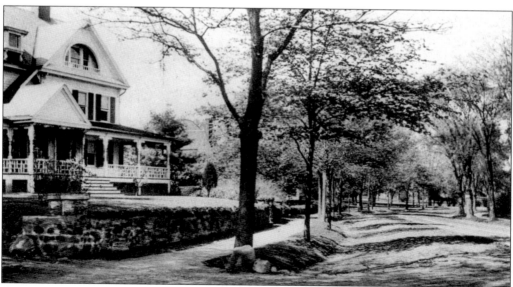

ATTRACTIVE FEATURES. As a member of the first board of health in Fanwood, Burton Hall made this his residence in 1885. Located on North Avenue, this is a classic Queen Anne–style house with a slate gable roof, showing square and hexagonal shingles with a copper ridge. Decorative wooden shingles on the second floor give a special appeal. There is a double front door and a porch around the first floor with turned column supports.

A CORNER VICTORIAN. Dr. Frank Wescott was the first and only physician in Fanwood until 1924. Serving as borough physician for just $1 per year, he also invested in real estate and enjoyed living in this Queen Anne–style home built in 1890. With its heavy cornice and trim, brackets under the eaves, and gable-and-hipped roof, it is a good example of the style prevalent in the late 19th century.

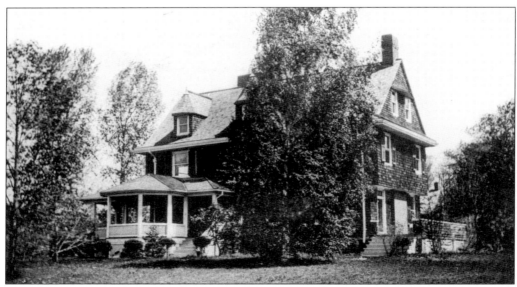

THE J. P. STEVENS HOUSE. The owner of several textile mills and founder of the textile company that bears his name, J. P. Stevens was also an active member of the community, serving in the Fanwood Fire Company in 1894. His home, built in 1896 on Forest Road, still stands proudly, surrounded by handsome trees and shrubs. The European Turkish red oak to the left of the property is the largest of its species in New Jersey.

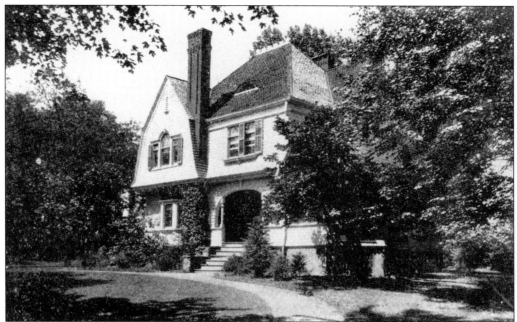

THE WALTER S. FORCE HOUSE. This house, built in 1892, was the residence of the first borough tax collector and, later, of Dr. Ray Thomas Munger, chief surgeon of Muhlenberg Hospital. In 1926, it was owned by Ragner Hasselgren, Inc. This Dutch Colonial Revival house has been renovated by Jim and Barbara Vierschilling into a bed and breakfast. It looks out on the grounds of the railroad station on North Avenue.

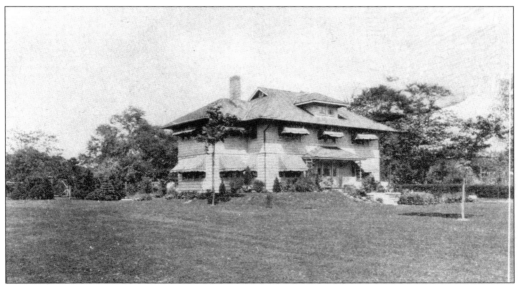

THE HAND HOUSE. Located on Martine Avenue, this house represents the Prairie Craftsman style of architecture. The hipped roof is characteristic, lending a stately quality to this *c.* 1923 home. Edward L. Hand resided here.

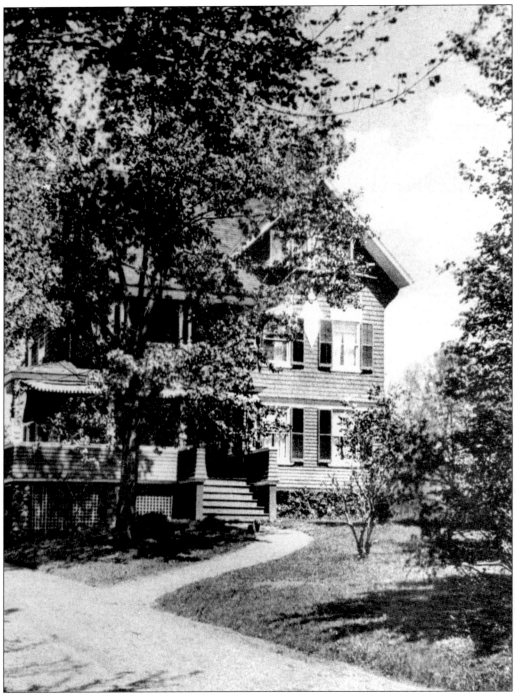

THE W. A. GARDNER HOUSE. With the stately grace of Victorian homes built in the 1890s, this typical Shingle-style dwelling is located on North Avenue. The house was also known as "the Bride's House," because J. P. Stevens lived in it with his new bride while awaiting completion of his own home on Forest Road.

THE NORTON HOUSE. In 1890, this home was built by A. D. Beeken, a member of the first Fanwood Borough Council. This Queen Anne–style house is situated on the corner of Martine Avenue and Paterson Road. Thomas Norton resided here in 1926.

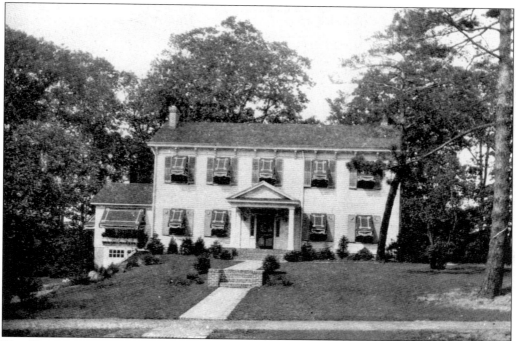

THE RANDALL-KYTE HOUSE. This fine example of Federal architecture was built in the midst of a quiet farming community c. 1790. The earliest known owner was W. Randall, according to an 1862 map. By 1890, the house was owned by John and Charles Kyte, and the two maiden Kyte sisters operated it as a boardinghouse on Martine Avenue.

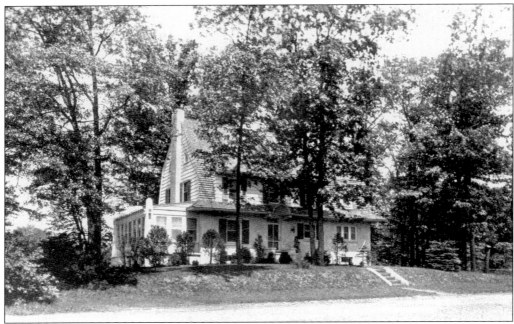

A LOCAL BEAUTY. This stately example of Dutch Colonial Revival architecture stands on the corner of Midway Avenue and Russell Road. Built in 1915, it was owned by Dr. Thomas Bickerton, a single gentleman who is said to have maintained the 15-room house with the help of his Japanese servant. A conservatory and ballroom dominated the downstairs. Back-to-back fireplaces warmed the large rooms. The current owners have made this an inviting family home.

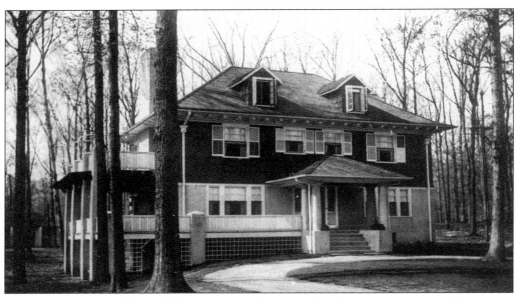

THE A. I. NICHOLS HOUSE. This impressive home on North Avenue was owned by the tax collector and holder of Fire Badge No. 1. In 1964, the estate was sold and subdivided. More than a dozen homes now surround the original mansion in a cul-de-sac.

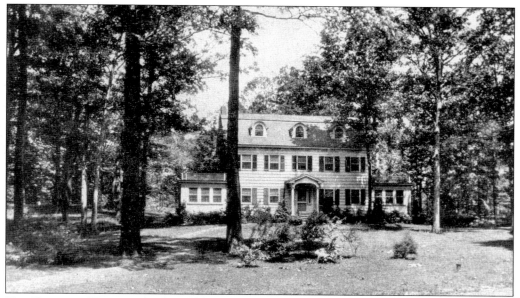

THE PRESTON HOUSE. This handsome house on North Avenue was the residence of Thomas Preston. Note the French-style dormers set into the gambrel roof.

VICTORIAN SPLENDOR. Built by Cornelius Martine in 1891 for $3,300, this house was purchased by the Reilly family in 1893. The house stood empty from 1910 to 1921. During this time, the house became temporary shelter to transients, who stayed warm in front of its eight fireplaces. Subsequent homeowners and guests claim to have seen ghostly apparitions wandering in the halls. The house is now undergoing a complete restoration.

THE TODD HOUSE. This is the home of one of Fanwood's early mayors, John Livingston Todd, who served in that position from 1910 to 1911. The house was next owned by Frank E. Weldon, founder of Fanwood Crushed Stone, also known as Weldon Quarry. Weldon reared his family in their early years in this elegant Neoclassical-style dwelling on Martine Avenue.

MAYOR YOUNG'S HOUSE. The residence of Fanwood's first mayor, Thomas Young, this house was located in the area bounded by Woodland Avenue, Forest Road, and Midway Avenue. It has since been replaced by contemporary homes.

THE WEDDING HOUSE. Benjamin Urner was a wealthy and generous father, who likely built this elegant house as a wedding gift for his daughter. In 1887, she married William M. Gibbs, a mechanical engineer who worked on sound-recording devices with Thomas Alva Edison. This Georgian Revival home, the only example of its kind in Fanwood, was built in 1894.

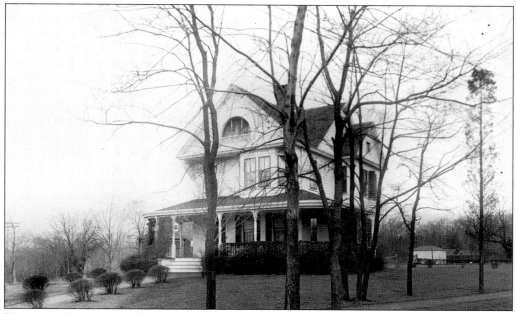

HISTORIC ELEGANCE. This home, owned by William Outwater, stood at the intersection of Tillotson and Forest Roads in the early 1900s. The house is no longer standing.

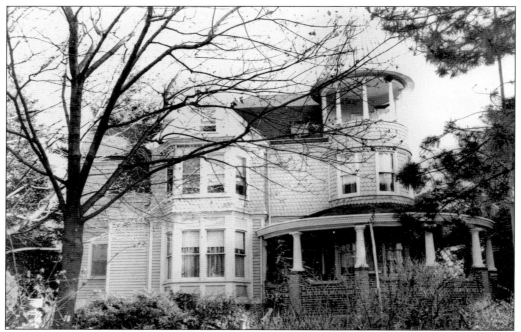

313 SOUTH AVENUE. This beautiful mansion, looking upon South Avenue, was torn down in the 1950s. Curved shingles on the upper part of the house and the rounded portico and stately columns made this home an impressive sight. An office building stands in its place today.

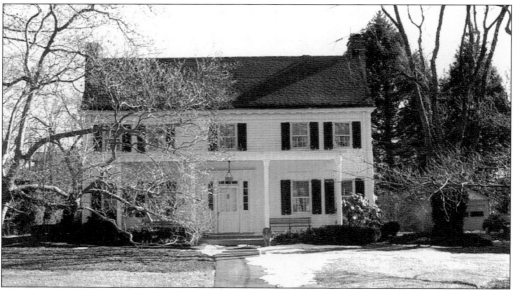

A COLONIAL REVIVAL. Built in the early 1900s, this North Avenue house has the charm of a much older home. With a broad entranceway, the expansion of the house over the years has made the downstairs seem much larger than it must have been in its early history. A striking pair of staircases ascending to the third floor accent the entranceway. The stairwell was so high that it accommodated an 18-foot Christmas tree.

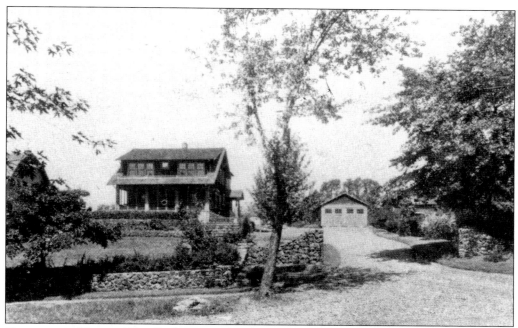

CRAFTSMAN HOMES. The Craftsman style, characterized by gently sloping roofs and porches across the front, was often used in the early 20th century. Craftsman-style homes were usually one and a half stories high and were designed for low maintenance. Column supports, open-end rafters, and stone fireplaces also appeared in some of these houses. This home still stands on Russell Road, one of many examples of the style throughout the borough.

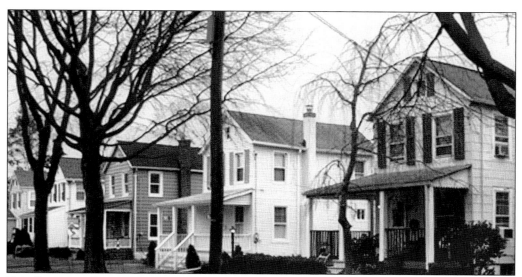

THE STEWART PLACE HOUSES. The Hand Lumber and Coal Company built 10 houses on this street and on Terrill Road *c.* 1905. Many of them became dwellings for the men who worked on the railroad and their families. The neighborhood was known as Handville among the residents.

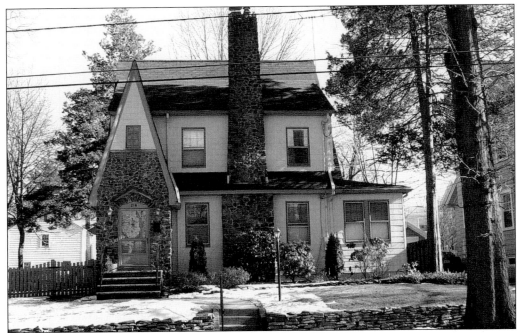

A WESTERN ELECTRIC HOME. In the late 1920s, Fanwood's population boomed, triggered by the fact that four trains ran each day to the Western Electric plant in Kearny. The Cooperative Realty Corporation of America, owned by Western Electric employees, built homes like this one for company commuters.

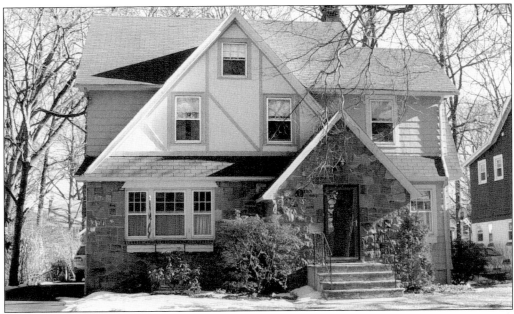

FANWOOD TO KEARNY. Fairview Estates, built by James Swann, encompassed Cray, Chetwood, and Kempshall Terraces. Homes there ranged from $8,200 to $9,300. Shown is one from that original development. Because of this expansion, Fanwood's population nearly doubled.

Three
THE GUARDIAN ANGELS

Without a strong system of protection, a community could easily disintegrate. From its earliest days, Fanwood has had a cadre of volunteers and professionals who have watched over its residents. The needs are endless: a house catches fire, someone is injured in an accident, or snow from a winter storm blankets streets and parking lots. Police and public works employees, along with volunteer firemen and first-aid squad members, are always on the job, making this borough a well-cared-for and safe place in which to live.

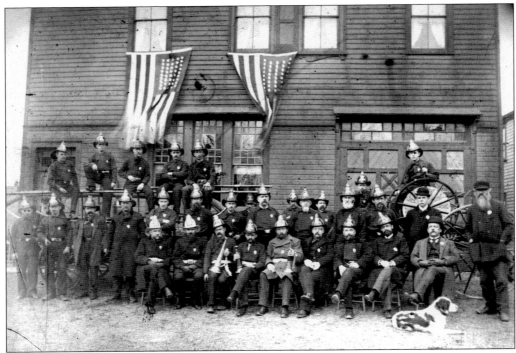

THE EXCELSIORS. In 1880, Fanwood Township was composed of the two communities we know today as Fanwood and Scotch Plains. In this photograph, members of the Excelsior Fire Department pose in front of their firehouse in fire-fighting gear, with their mascot nearby.

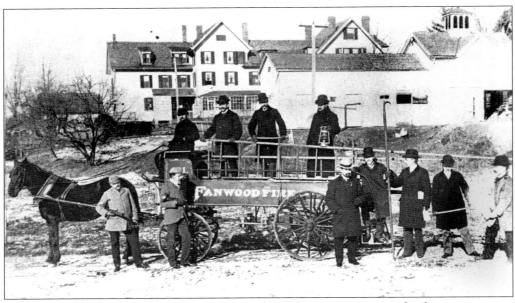

THE EARLIEST MEMBERS. The original Fanwood Fire Company wagon and volunteers are seen here on Watson Road. In the background is the Homestead Hotel and its carriage house.

FIRE EQUIPMENT. The original hand-drawn hose cart of the Fanwood Fire Company was donated by the Central New Jersey Land Improvement Company, the real estate arm of the Central Railroad. This equipment was initially sheltered in private sheds. It was restored by members in 1975 for use in parades and special events.

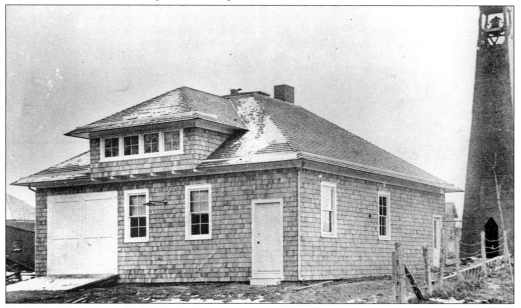

THE NEW BUILDING. In 1897, the fire company purchased a piece of property on Watson Road for $250. The members hosted a public dance and housewarming party to celebrate the new building and its 50-foot bell tower. In February 1900, the borough of Fanwood entered an agreement to rent two rooms to be used for offices and the police department.

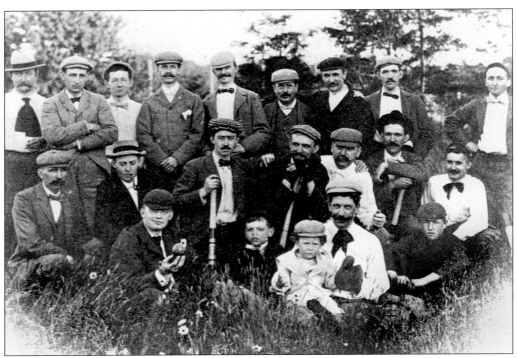

CELEBRATING. The fire company picnic was a major social event in the new borough of Fanwood in 1897.

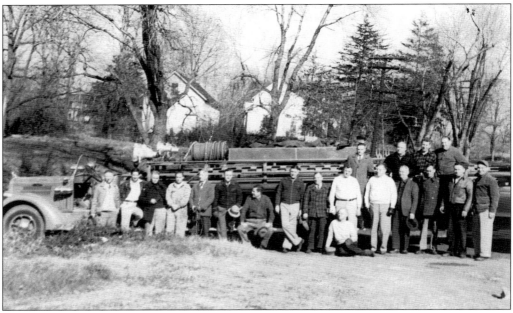

NEW EQUIPMENT. In 1936, the borough purchased Engine No. 2, which featured a fire pump, a water tank, ladders, and more than 1,000 feet of hose.

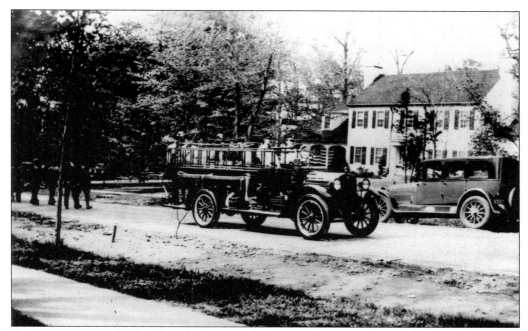

THE REO. Fanwood's Reo Speed Wagon makes its annual appearance on Martine Avenue in the Memorial Day parade.

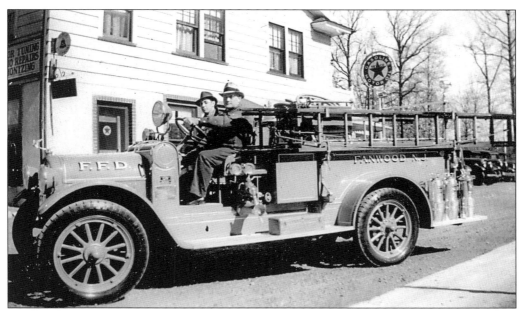

REFUELING. The Reo Speed Wagon gasses up at the Pointe Inn Luncheonette and Gas Station on South Avenue.

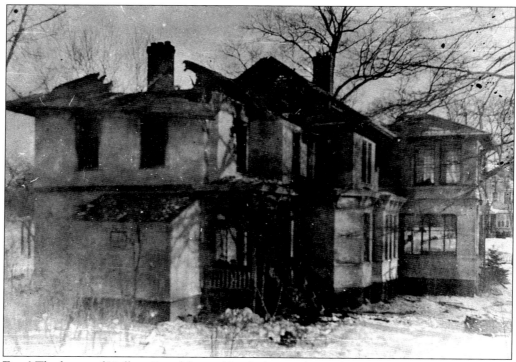

FIRE! The home of Hulbert Beardsley on North Avenue burned in January 1936. While the fire chief was fighting the stubborn blaze, his coat froze due to the frigid weather.

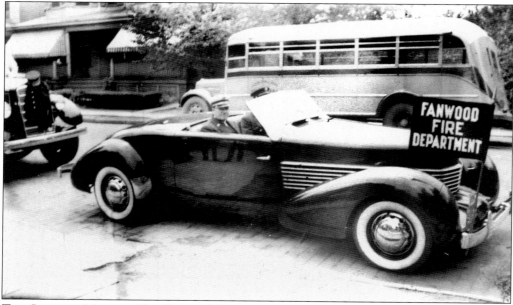

THE LINE OF MARCH. The Fanwood Fire Company regularly participated in the Atlantic City parade.

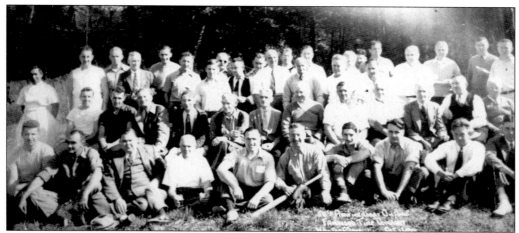

A COMMEMORATION. One of the several events commemorating the 50th anniversary of the fire company was a picnic held at Hilltop Grove in Berkeley Heights on October 13, 1940.

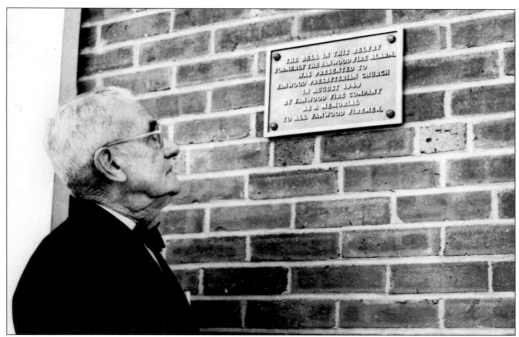

A PRESENTATION. On August 16, 1949, A. I. Nichols, a firefighter with 49 years of service, presented the bell from the original firehouse tower to the Fanwood Presbyterian Church as a memorial to Fanwood's firefighters.

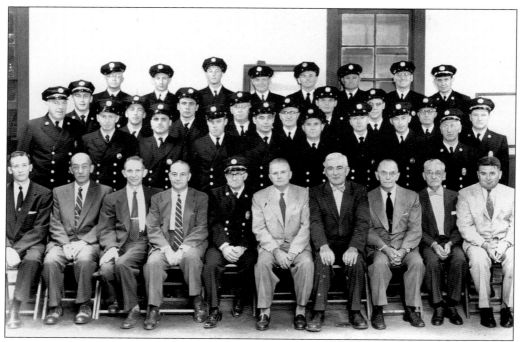

THE ANNUAL PHOTOGRAPH. The fire company appears for its annual report photograph in the old fire hall on Watson Road in 1955.

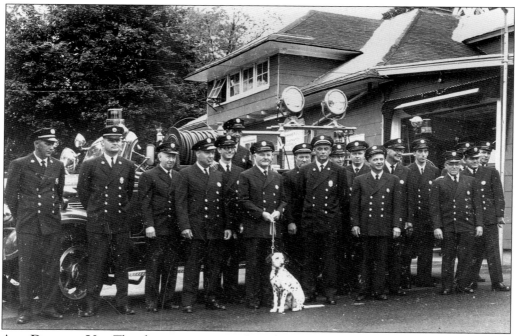

ALL DRESSED UP. The department poses for a pre-parade photograph at the fire hall on Watson Road in 1965.

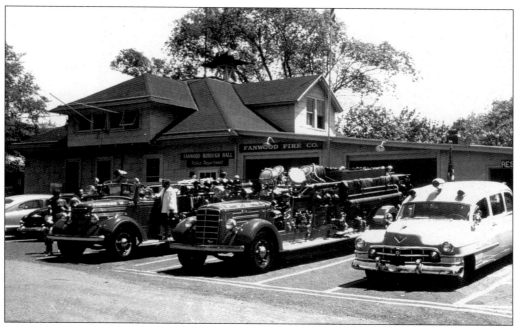

Nice and Shiny. All vehicles were buffed and polished for an open house in 1955.

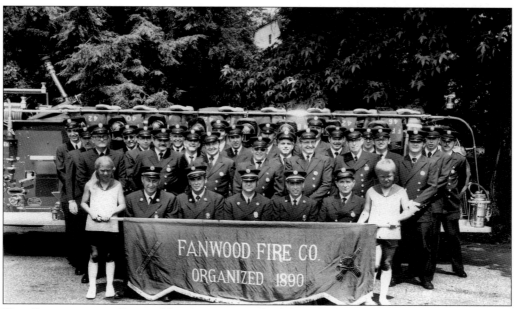

The Background. Engine No. 4 serves as a backdrop for fire company members, who are dressed for the 1974 Memorial Day parade.

MEMORIAL DAY. The 1958 Memorial Day parade brought out a strong showing by the fire company. The parade always attracts crowds from the community, who cheer on the local volunteers.

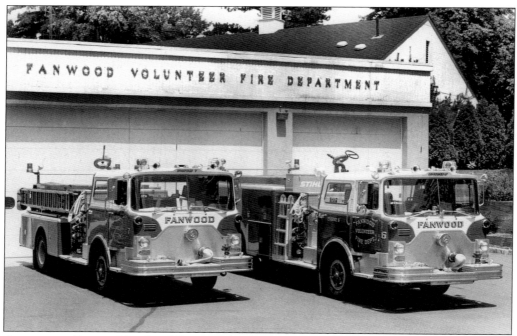

ADDITIONS. Engines No. 6 and 7 joined the fire department in 1982.

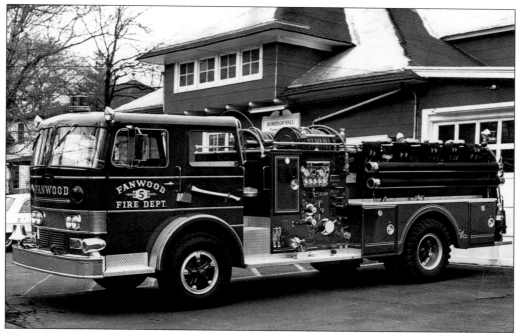

UP TO DATE. Fanwood's first modern truck, Engine No. 5, was a triple-combination cab-over designed by Great Eastern.

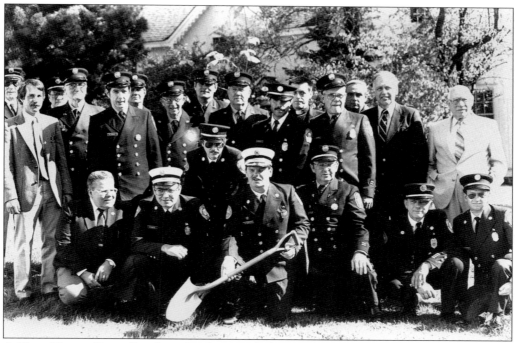

A NEW HOME. Groundbreaking for the new firehouse took place on October 16, 1983, with the participation of firefighters and borough officials.

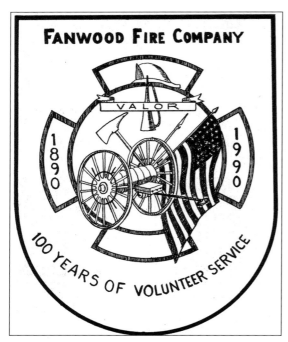

ARTWORK. The logo for the 100th anniversary of the Fanwood Volunteer Fire Department was designed by local high school student Sara Ahnert.

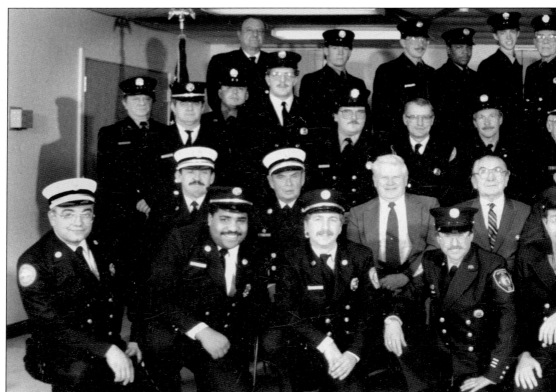

THE PROUD MEMBERS. The department poses for its 100th-anniversary photograph.

50

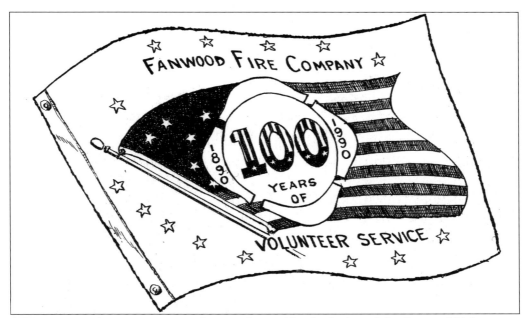

A Donation. A commemorative flag was donated by the Ladies of the Fanwood Volunteer Fire Company for the 100th anniversary.

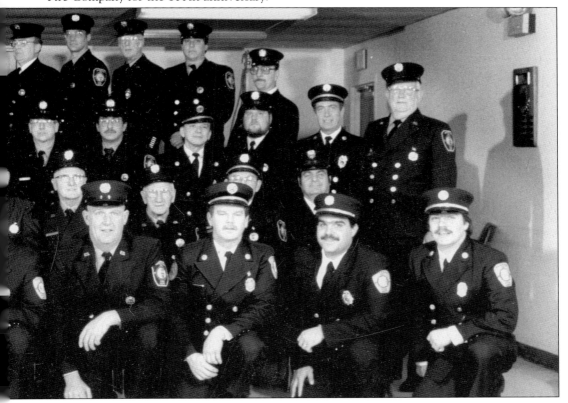

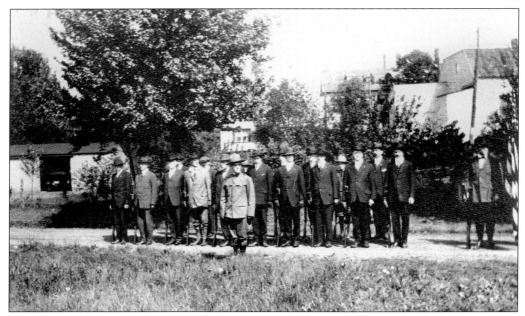

MARCHING. Fanwood's home guard, the Fanwood Militia, drills on the firehouse grounds during World War I.

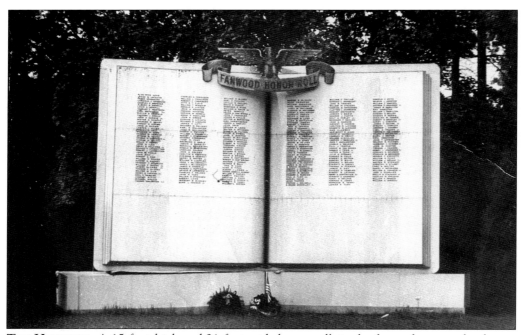

THE HONORED. A 15-foot-high and 21-foot-wide honor roll, in the form of an open book, was erected on the south side of the Fanwood railroad station to salute residents of Fanwood. The names of 227 men and women appeared on the original roll, and gold stars marked the names of those lost in battle.

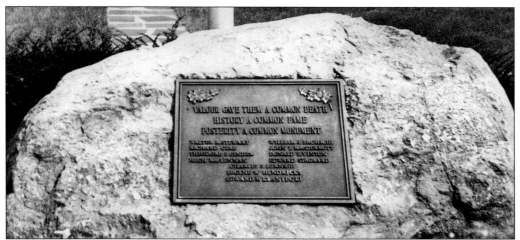

IN MEMORIAM. A bronze plaque on a natural stone in front of the Fanwood Memorial Library names the men who lost their lives in World War II, the Korean War, and the Vietnam War. The plaque, dedicated in 1969, reads as follows: (first column) Walter R. Stewart, Richard Gere, Charles Burns III, Theodore Ginder, Hugh MacLennan, and William J. Brohm III; (second column) John T. MacDermott, Donald Vinton, Edward Stagaard, Eugene W. Hendricks, and Edward M. Klaniecki.

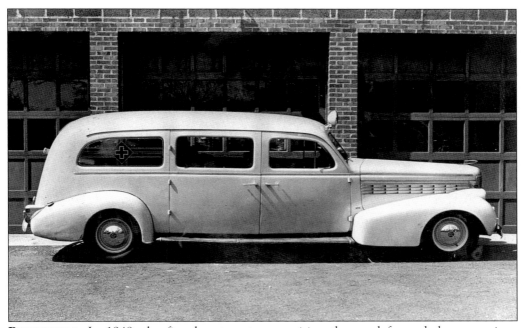

BEGINNINGS. In 1948, the fire department, recognizing the need for ambulance services, organized a separate and independent rescue squad with 30 charter members. This 1938 LaSalle ambulance, purchased for $1,000 from the Scotch Plains Rescue Squad, was the department's first ambulance.

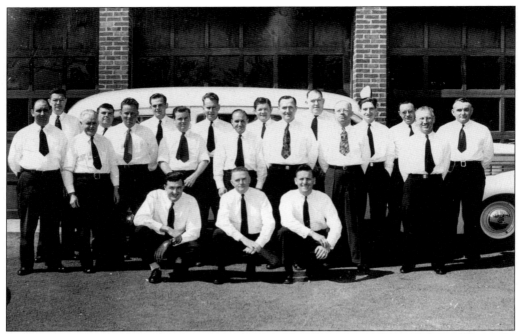

FIRSTS. Charter members of the Fanwood Rescue Squad appear in front of the public works building in 1948.

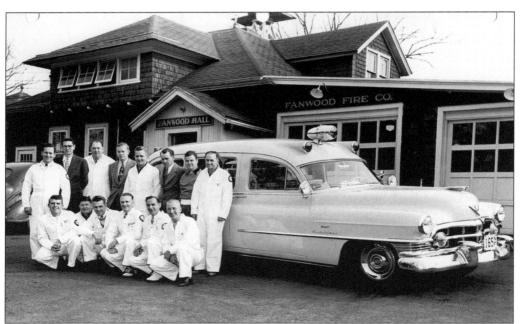

ANOTHER GROUP. Gathering in 1953, members of the rescue squad are proud of their Miller Meteor Cadillac ambulance, acquired for almost $8,000. Pictured here, from left to right, are the following: (first row) unidentified, McCarthy, Nillendir, Matthews, Menoff, and Kraus; (second row) Burns, Yarnell, Stocker, Hoffsmith, Gundy, Rose, Day, and Haer.

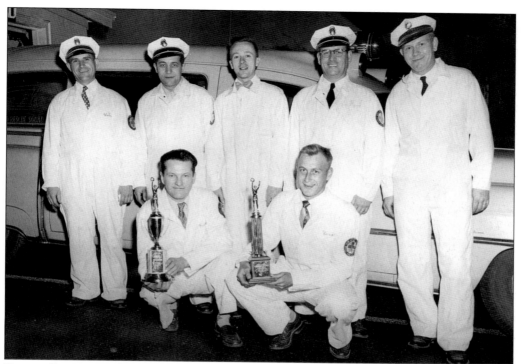

PRIZES. Rescue squad members are proud of their first- and second-place trophies, won at the Carteret First Aid contest in 1954.

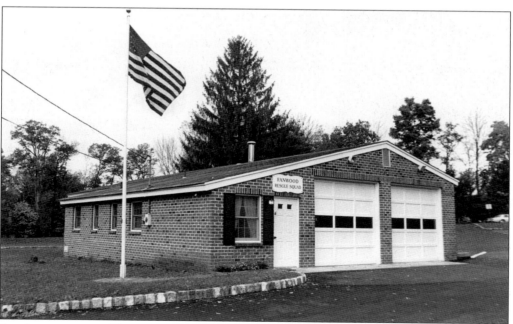

AN ACHIEVEMENT. The rescue squad realizes its dream with the dedication of its own building on September 25, 1977.

THE POLICE CHIEF. William Logan served the borough for 15 years, starting as a night marshal for $50 a month. Later, he provided borough protection during the day for an additional $24 a month, plus a new uniform and a bicycle. Sadly, Chief Logan died when, while chasing hoboes on the railroad track, he was struck by a pusher engine running backward on the eastbound freight track.

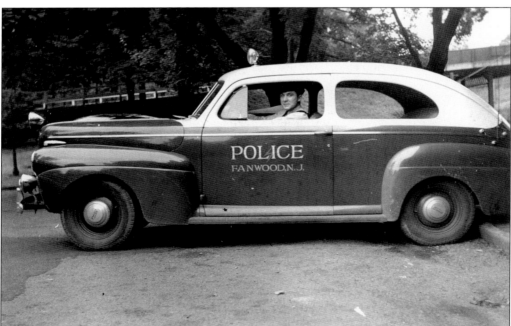

PROTECTION. In 1941, police patrol cars cruise the north-side train-station parking lot adjacent to the Martine Avenue railroad crossing.

CRIME DOES NOT PAY. This jailhouse made of cinder blocks and steel was located at the public works garage on North Avenue.

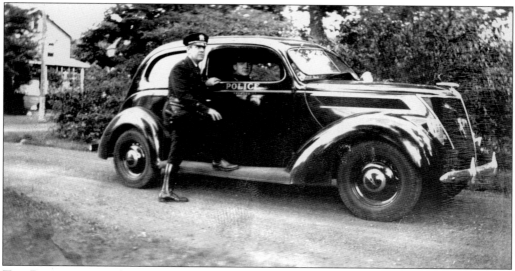

THE PROTECTORS. Chief John Brady and officer Joseph Gorsky, who later became chief, stand by a police car in the 1930s.

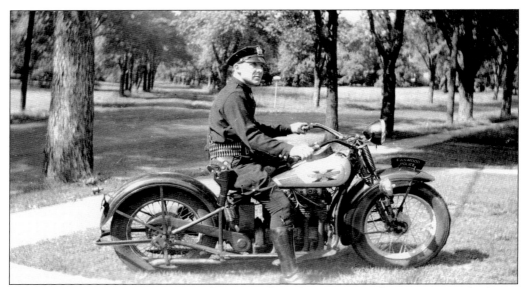

THE WHEELS. Officer Gorsky patrols Fanwood on his 1928 Henderson motorcycle during the 1930s.

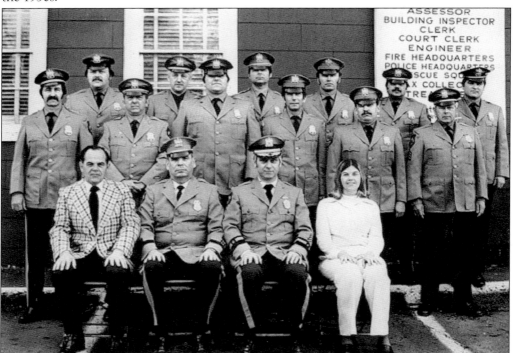

THE MEMBERS. Fanwood Police Department members, pictured in front of borough hall on Watson Road in 1975, are from left to right, as follows: (first row) Lt. Charles Persson, Capt. George Germinder, Chief Anthony Parenti, and secretary Kathy Weldy; (second row) Norman Fourre, Robert Furchak, Howard Jarvis, Peter Wehr, Thomas Rose, and Sgt. William Hannon; (third row) Thomas Radnoich, Sgt. Jack Heldebrant, Richard Messerau, James Pasko, Timothy Mondoro, and Joseph Petersen. Sgt. Earl Phillips took the photograph.

Four
FEEDING THE
SPIRIT AND THE MIND

Education, houses of worship, and cultural groups give a community its heart. Schools, churches and the library were established early in Fanwood's history. From small beginnings, these meeting places developed into effective local centers of learning, spiritual growth, and inspiration. These photographs display the people and places that have made a difference in the lives of Fanwood residents.

CARRIE BETTMAN. A teacher for many years at the old parish schoolhouse in Scotch Plains, Carrie Bettman became the first librarian and first postmistress in the building on Martine and North Avenues. Since these two offices did not connect, book borrowers had to select their books and then go through the door to the post office to check them out.

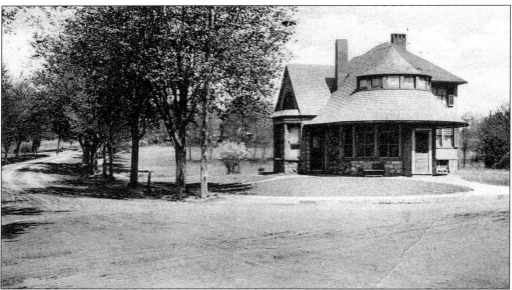

THE FIRST LIBRARY. Here, in the first post-office building, on Martine and North Avenues, the Fanwood Free Public Library began. A group of women contributed its book collection and $26 in 1899, and the borough added $25 for the first year of maintenance. The first regular librarian was appointed in 1919. In 1928, with the post office moved to another location, the library took over the whole building.

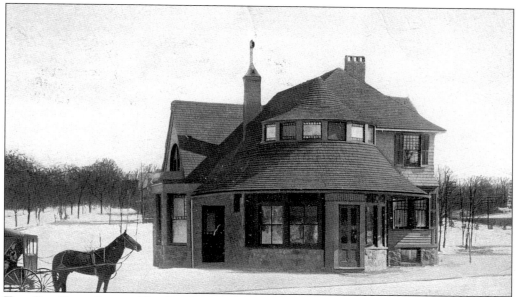

THE OLD POST OFFICE. The first Fanwood post office was built in 1897 in the Richardsonian Romanesque style. Located on Martine and North Avenues, this building is a traditional landmark of Fanwood. The rough-faced squared stonework, conical roof line, and large eyebrow dormer are its unique features. It was constructed by the Central Jersey Land Improvement Company and was given to the borough.

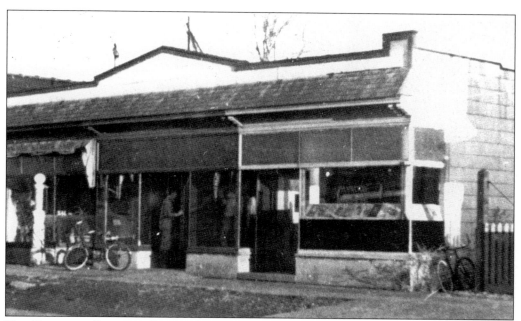

THE FANWOOD LIBRARY. During the 1940s, the Fanwood Library moved to a South Avenue storefront. The move took place to accommodate the growing collection of books and an expanding circulation. Janet B. Carter, the librarian for 13 years, supervised the transfer of books. Following her resignation, Olive Harris was appointed librarian.

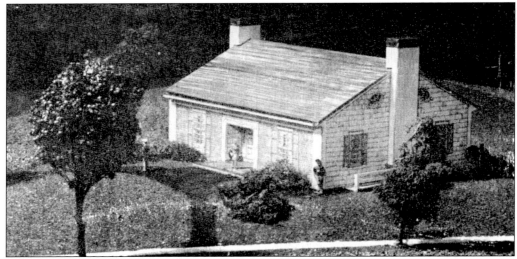

A New Home. The first part of the current Fanwood Memorial Library was opened in 1951. It was named in memory of local men who lost their lives in the service of their country. Constructed at a cost of $45,000, it was the first building constructed by the borough since its incorporation in 1895. This is an architect's rendering of that original building.

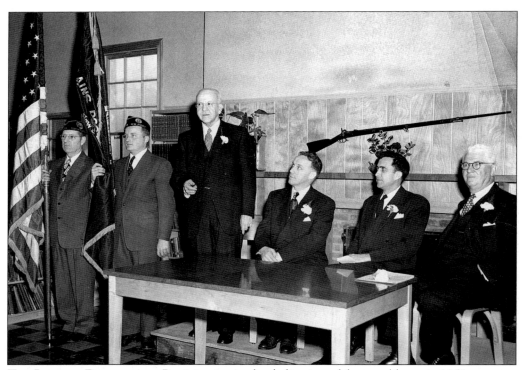

The Library Dedication. Participating in the dedication of the new library in 1951 are town fathers, from left to right, Clarence Lehlback, Charles Ferguson, Mayor Ronald Riblet, Councilman Ralph Russell, Rev. Noel Calhoun, and Hon. Carl O. Sayward, who was mayor from 1934 to 1937.

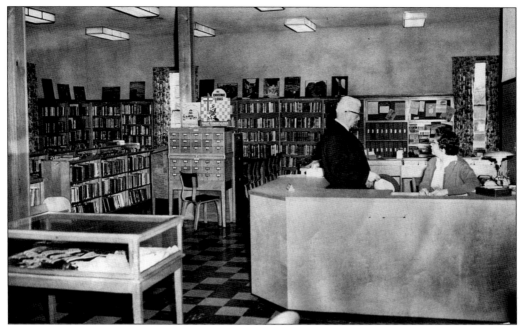

THE LIBRARY INTERIOR. Mayor Carl Sayward and Margaret Beldon confer in the library in 1966. Note the card file, which has long since been replaced by a computer, to look up the location or availability of a book.

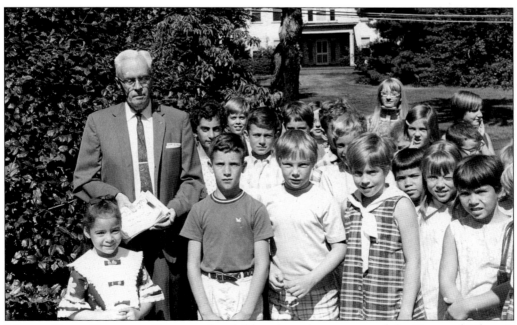

MAYOR TODD PRESENTS. Programs for children have been a part of the Fanwood Library's agenda for many years. Here, Mayor Charles Todd presents reading awards to a group of high achievers.

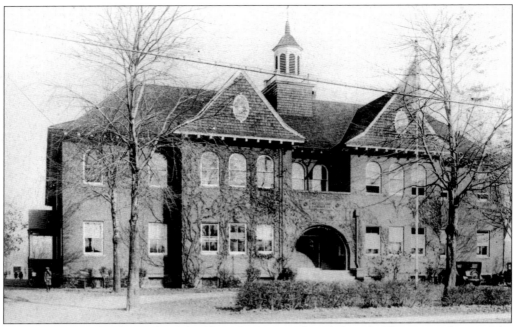

SCHOOL ONE. The first school building for Fanwood and Scotch Plains was designed by architect Stanford White. Located on Park Avenue in Scotch Plains, it was constructed in the 1890s and was said to be the talk of the town. Some residents felt it looked more like an asylum than a school. Nevertheless, children attended this school for many years. Sadly, in 1984, it was destroyed by fire.

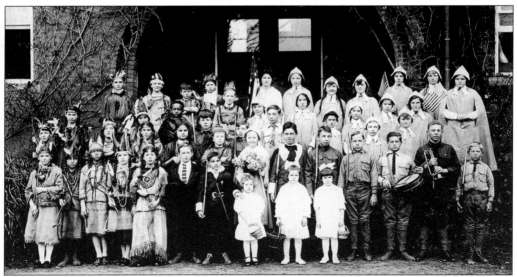

SCHOOL ONE STUDENTS. From the looks of their costumes, these School One youngsters have a play on the day's schedule. This 1913 photograph shows Fanwood's future mayor Richard Hatfield standing with his musket at the ready in the front row seventh from the left. One of Fanwood's oldest residents, Helen Lindsey, appears ninth from the left.

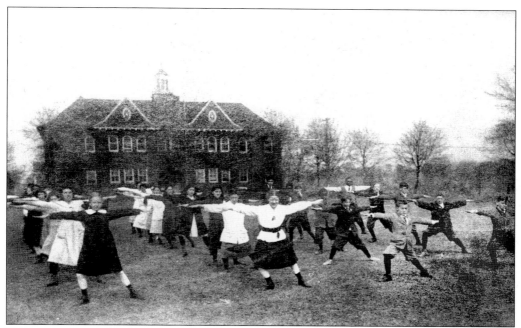

WARMING UP. School One students get the day started in front of the building in an early photograph. Note the more formal attire, as compared to the current outfits worn by children.

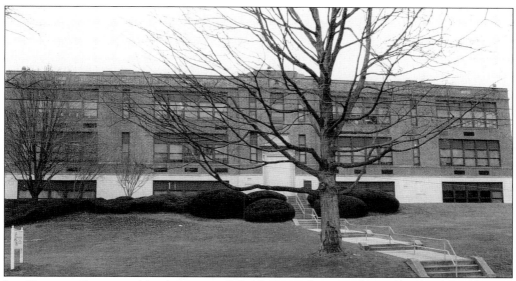

LA GRANDE SCHOOL. Also known as School Four, this was the only school building in Fanwood. It was built in 1923 at a cost of $87,268. A lunchroom and candy store on South Avenue provided a place for students to dine. After the school closed in 1978, Fanwood children attended school in Scotch Plains. The building now houses a branch of Mountainside's Children's Specialized Hospital.

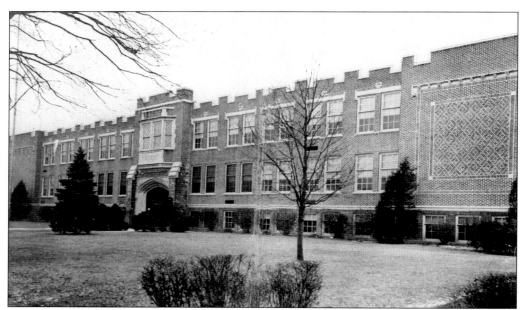

THE FIRST HIGH SCHOOL. Fanwood teenagers attended high school in Scotch Plains. This building was constructed in 1926 on Park Avenue and served as the high school until 1958. It became a junior high and is now a middle school for grades five through eight. Many alterations have been made to Park School over the years.

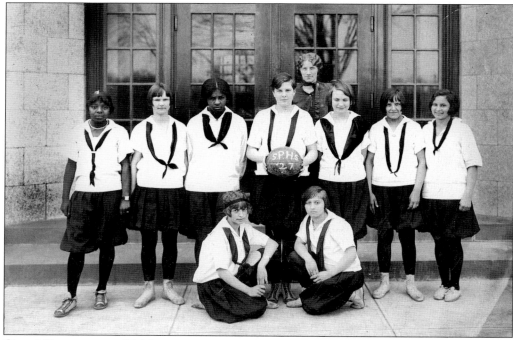

GIRLS' BASKETBALL. Girls' sports were important even in 1927. Here, members of the high school basketball team pose at Park School.

HOWARD BRUNNER. As principal of the original high school and, later, as superintendent of schools, Howard Brunner devoted many years of his professional life to the education of children in the communities. The Westfield Road elementary school has been named in his honor.

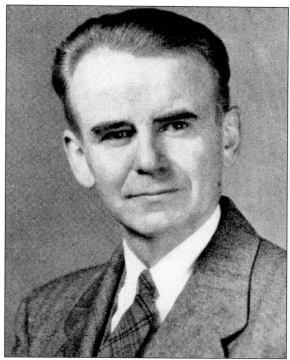

ROBERT ADAMS. Principal of Scotch Plains–Fanwood High School from 1941 until 1966, Robert Adams supervised the move of the high school from the building on Park Avenue to its current location on Westfield Road. He was noted for his quiet persistence and had the unique qualification of being certified to teach English, Spanish, physics, science, and math.

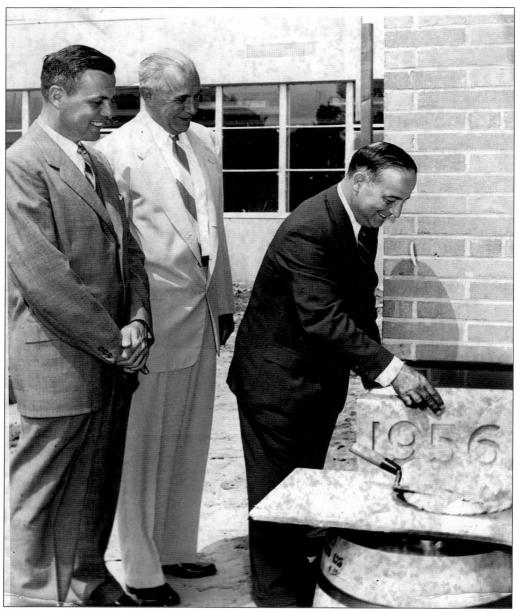

FOR POSTERITY. Board of education member Henry Ernst, Scotch Plains mayor Dr. William Sampson, and Fanwood mayor Richard Hatfield share in the work of laying the cornerstone for the new high school building in 1956.

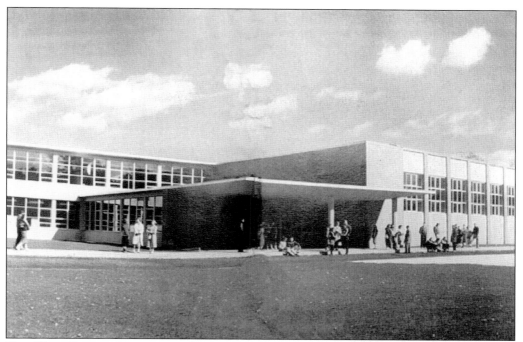

THE HIGH SCHOOL BUILDING. The first section of Scotch Plains–Fanwood High School was completed in 1958. A major addition was constructed in 1969, followed by another renovation and addition in 2003. Currently, about 1,350 pupils attend grades nine through twelve. Noted Fanwood graduates include actress Sada Thompson; Billy Austin, an all-American from Rutgers; and Carol Bellamy, a part of the United Nations leadership.

THE DRUM MAJORETTE. This spirited young lady, Elaine Klein, led the marching band for the high school in 1946.

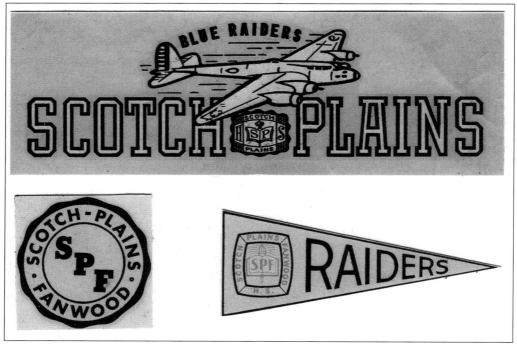

THE ORIGIN OF THE BLUE RAIDERS. Until the 1940s, the high school teams were known as the Plainsmen. As part of the war effort, students decided to raise funds to buy a B-17 bomber. History teacher Catherine Mingle organized the sale of decals to promote this ambitious goal. This decal was designed for the project, and the teams became known as the Blue Raiders. Though it was Scotch Plains High School then, Fanwood sent its students there.

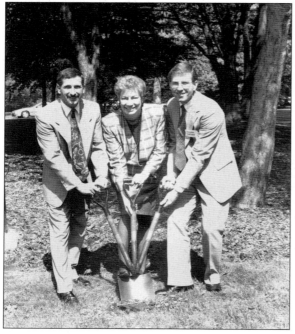

THE YMCA ADDITION. Although the local YMCA is in Scotch Plains, it has always served both communities. When the YMCA outgrew its facility on Grand Street, a new building was constructed on Martine Avenue in 1971. An addition was built in 1993. Here, director John Ciambrone, board member Carol Wood, and board president Tom Luciano break ground for this new complex. Wood was from Fanwood and also served on the borough council.

WOODSIDE CHAPEL. With its congregation's first meetings held in the YMCA in Westfield in 1920, the non-denominational chapel began to take shape on the Fanwood site in 1950. The first meeting there was in 1952, with 12 families attending. Since then, there have been two additions to the building, and 70 families are now part of the congregation. Dr. Jack Gill and Arthur Mayer, who bought the Darby-Hetfield House, were the founders of the chapel.

THE BUDDHIST CENTER. This house of worship on Midway Avenue was occupied by the Christian Science church for many years. It is now the Dhammakaya Meditation Center, open to all faiths and denominations. This international organization chose to locate in Fanwood because of the calm atmosphere and tranquil environment so well suited to meditation.

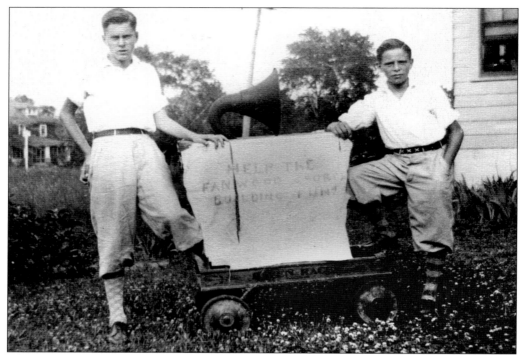

FUND-RAISERS. Beginning as a non-denominational fellowship meeting in La Grande School in 1929, the 39 charter members in 1932 affiliated with the Presbyterian church and launched a building fund. Warren Sims and Robert Layman, pictured here, canvassed door-to-door to raise the first $2 for the church building fund. This photograph was placed in the cornerstone of the original church.

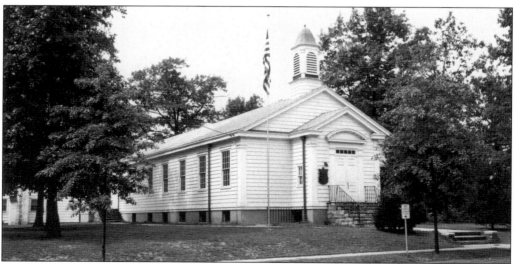

A LITTLE WHITE CHURCH. Dedicated on November 18, 1934, the Fanwood Presbyterian Church, on Marian Avenue, became the first church within borough limits. With membership on the rise, the church was expanded by 30 feet, and an education building was constructed in 1948.

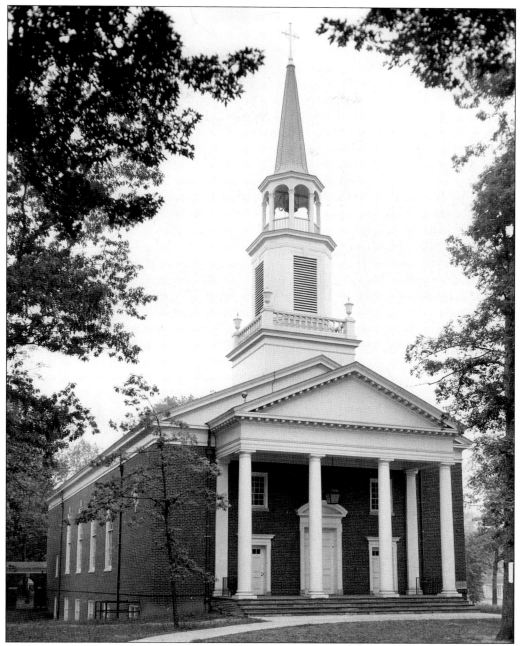

ITS STATELY SUCCESSOR. Mirroring the booming growth of the community during the post-war era, the Fanwood Presbyterian Church's congregation hailed from many states and many different religious affiliations. Outgrowing its original home, the sanctuary building of today was dedicated on September 21, 1958, with its front doors facing Martine Avenue.

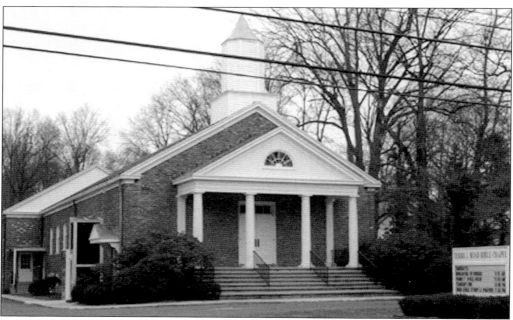

TERRILL ROAD BIBLE CHAPEL. This fellowship began as the Brethren Assembly in Plainfield in 1870. Louis Rheaune is the only name from this original group remaining on record. In 1957, the cornerstone for the present chapel was set in place by Phillip K. Carter, Milton G. Wistner, F. Parker Loizeaux, and John Reid. More than 500 people attended this ceremony. The first church service was conducted in May 1958.

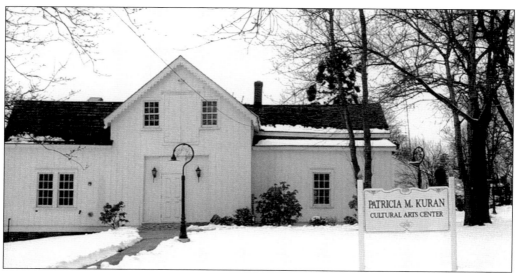

THE CARRIAGE HOUSE. This structure is now known as the Patricia Kuran Cultural Arts Center, named after Fanwood's first female mayor. She was instrumental in saving the building to be used for art exhibitions and performances. For years, it was home to the Philathalians, Fanwood's community theater group. Poetry readings and musical programs are the more recent cultural offerings in this last remnant of the Homestead.

Five

THEY LED THE WAY

Since the borough's inception, Fanwood's leaders have always emerged to carry out the requirements of government. The ordinances, budgets, committees, and commissions fall under the aegis of the mayor and the borough council. These are, in essence, voluntary positions, requiring endless hours of commitment. Each mayor has left a particular mark of achievement, and several have gone on to higher political levels. Here are just a few of the men and women who have met the challenges of leading the community.

THOMAS YOUNG. This gentleman was a town father in the truest sense. He served as the first mayor of Fanwood for four years and was always interested in civic affairs. He was the father of Horace Young, one of the town's postmasters. Thomas died in 1917 at the age of 86, having been honored by the Central Railroad as the oldest commuter to New York on its line.

A BALLOT BOX. On October 1, 1895, voters had the opportunity to decide the fate of Fanwood. Thirty-nine people voted in favor of the borough becoming independent from the township, while 18 opposed. This ballot box is not only a symbol of that spirit of rebellion but also a tangible reminder of Fanwood's past. It may be seen in the public library on Tillotson Road.

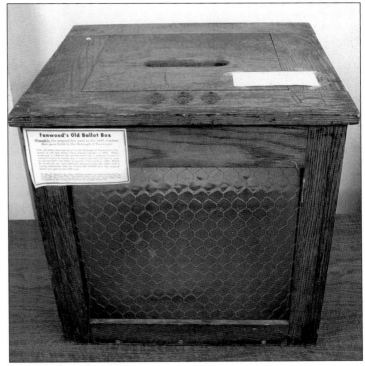

HORACE YOUNG. Born in Fanwood in 1875, Horace Grady Young was the son of the town's first mayor, Thomas Young. Horace, a member of the volunteer fire company when it first began, also served as tax assessor and postmaster.

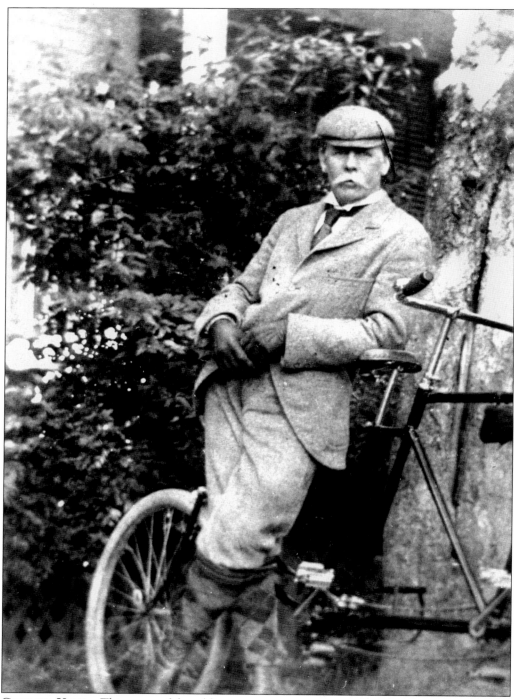

GEORGE KYTE. This powerful public servant was associated with the Central Land Improvement Company, which began a development of six houses along the Central Railroad tracks. He was deeply involved in All Saints Episcopal Church, a family affiliation for more than four generations. At the time of his death in 1900, he was mayor of Fanwood.

THE FOUNDER. Known as the "Father of Fanwood," George Kyte was a prosperous merchant who devoted much of his spare time to the town. He was born in Berlin, British Guiana, in 1846. During his life of public service, he also served on the Fanwood Township Committee several times, held a position on the Union County Board of Freeholders, and was a representative in Congress from District 3 of Union County.

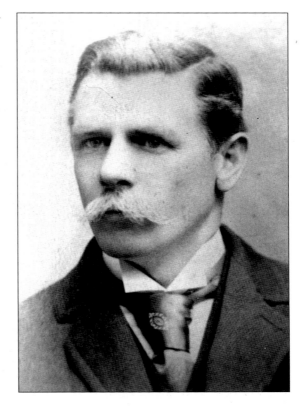

THE FIREMEN'S PICNIC. These handsome gentlemen, all Fanwood leaders, celebrated at the first firemen's picnic. Seen here, from left to right, are Gus Sheelen, E. Hand, Charles Sheelen, A. I. Nichols (mayor 1918–1923 and 1926–1927), G. Houghton, G. Huggins, and L. W. Lott (mayor 1928–1929).

JOHN LIVINGSTON TODD. This gentleman served as mayor briefly, from 1910 to 1911.

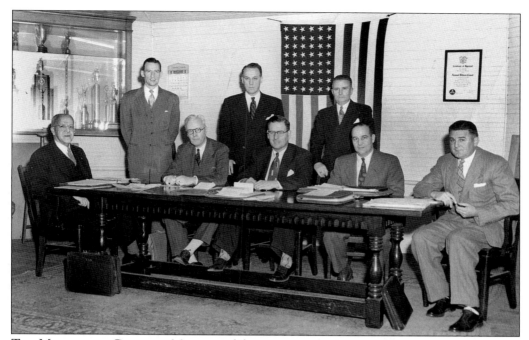

THE MAYOR AND COUNCIL. Meetings of the governing body were held in the firehouse room in the 1950s. This was a time of expansion for the community, when facilities were needed for town officials. During that time, the borough acquired a parking area from a local resident at the back of the fire hall at a cost of $3,500. An additional $35,000 was designated for renovation of the building.

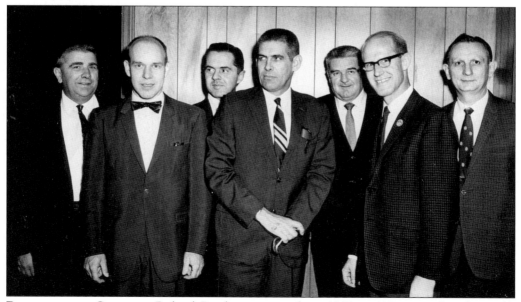

BEETHAM AND COUNCIL. Roland Beetham, mayor from 1968 to 1971, served with an all-Republican council. Pictured from left to right are Jerry Boryea, Douglas Beals, Charlie Smith, Roland Beetham, Jack Campbell, Van Dyke Pollitt, and George Greim.

PATRICIA KURAN. This first woman to serve as mayor of Fanwood held the office from 1984 until 1991.

THEODORE TRUMPP. Serving as mayor from 1972 to 1983, Trumpp held the office longer than any other. During his time as mayor, the old Homestead property was purchased for use as a municipal complex. Later, it was demolished to make way for the construction of new municipal buildings.

Six
TRADITIONS, CELEBRATIONS, AND RECREATION

Traditions—in the home, the schools, and the community—are the meat of history, enriching and linking generations. Parades, holiday festivities, Easter, and Halloween are a few of the annual markers that have given residents reason to cheer. Recreation lightens the challenges of life and gives families sources of bonding. Local parks are the playgrounds for young and old alike. And the camera has recorded many such moments of celebration in Fanwood.

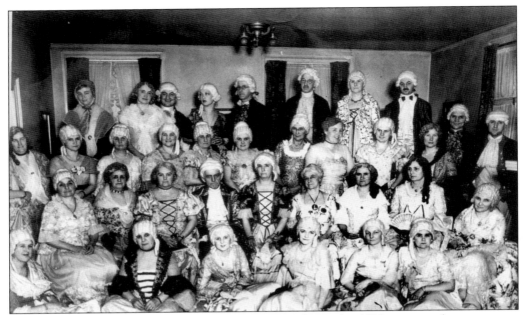

COSTUME PARTIES. Period costume parties were popular in the 1930s; many gala events were held at the Martine-Graham-Urner home, at the corner of Martine and North Avenues.

BATTER UP! A peat bog in the center of the planned ball field at La Grande Park burned for two months after a fire was intentionally set to dispose of the cut vegetation. A finished baseball field emerged in 1943.

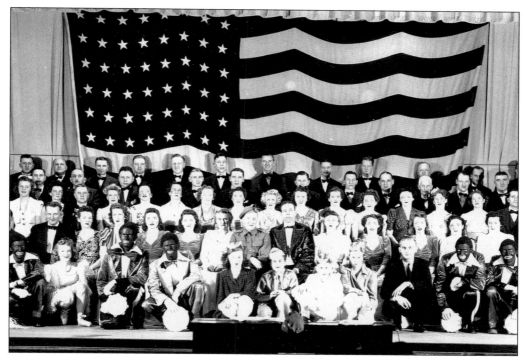

A Minstrel Show. A popular form of entertainment during the 1930s and 1940s was the minstrel show, a variety performance of songs, dances, and jokes. Here, a cast of local residents appears on a school stage.

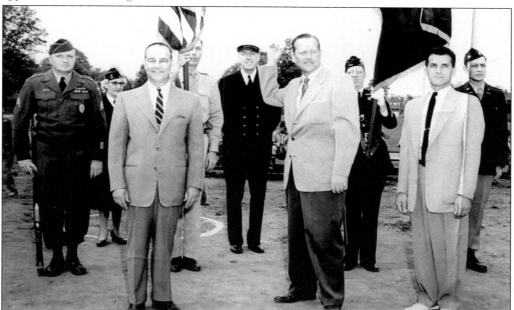

Play Ball! Fanwood mayor Richard Hatfield, left front, and Scotch Plains mayor Walter Jones, center front, inaugurate Little League play at the new high school field in this 1955 photograph. Members of American Legion Post 209 form the honor guard for the ceremony.

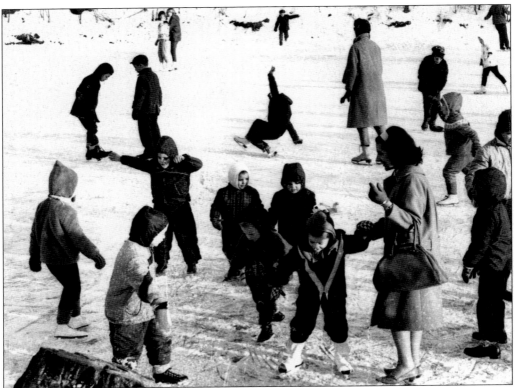

WINTER FUN. In this 1950 photograph, mothers lend a helping hand to their youngsters as they learn how to move and stay upright on the inviting ice at Happel's Pond, now the site of the high school on Westfield Road.

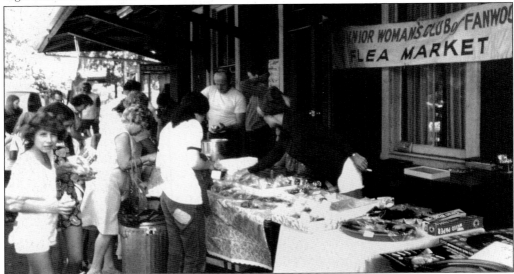

TRASH AND TREASURE. The north side of the old Fanwood railroad station was the most popular place in town to hold a flea market—the cultural phenomenon that raged during the 1970s, 1980s, and into the 1990s.

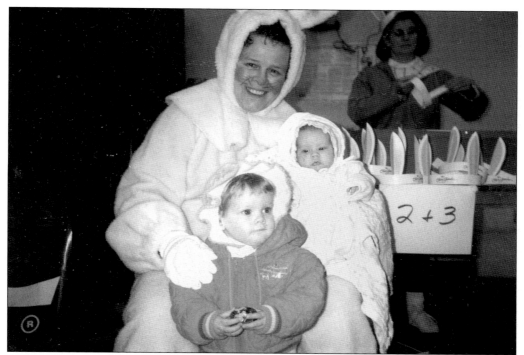

A Spring Search. Doris Terry is in the fourth decade of her role as Easter Bunny in the annual egg hunt conducted in the open area behind borough hall. Chelsea (left) and Lindsey Damberg get an extra hug from the bunny when the search is over.

We Remember. For many decades, Memorial Day has been observed with a ceremony and speeches at the Fanwood Public Library. Here, in 1961, Mayor Charles Todd acts as host at the microphone. Rev. Harold Scott (left) of the Fanwood Presbyterian Church is a participant.

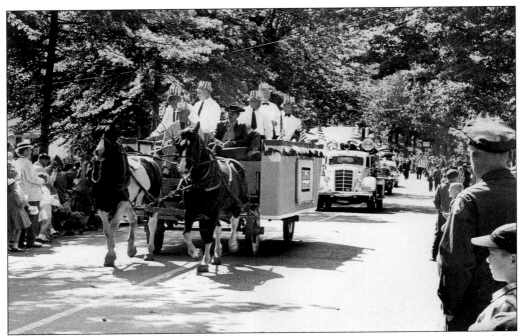

PARADE LOVERS. An overflow crowd of Fanwood residents observes the horse-drawn exhibit of the Elks Club as the Memorial Day parade of 1961 makes its way northward along tree-lined Martine Avenue.

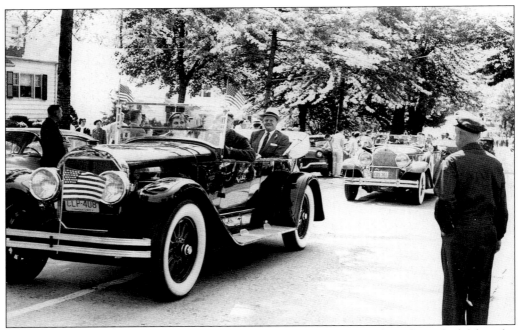

PROUD PARTICIPANTS. Successive generations of Fanwood residents have been faithful to the tradition of the Memorial Day parade. This section of the 1961 parade shows off antiques cars to memorialize the American love affair with the automobile in the 20th century.

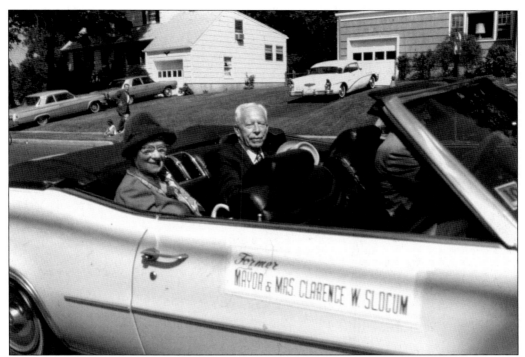

A COMMUNITY TEAM. Mayor Clarence W. Slocum and his wife enjoy their open-car appearance in Fanwood's 75th anniversary parade on Martine Avenue. Slocum served as mayor from 1930 to 1933.

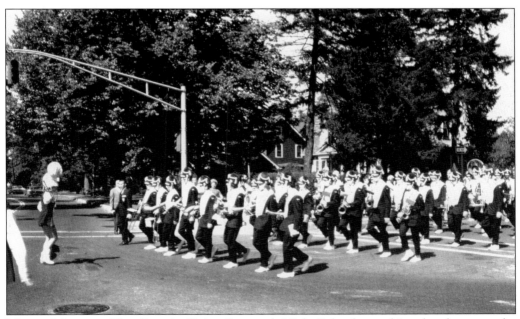

MUSIC MAKERS. The Scotch Plains–Fanwood High School marching band enters the intersection of Martine and Midway Avenues in Fanwood's 75th anniversary parade.

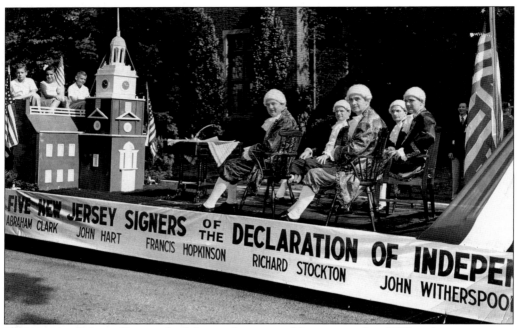

A HISTORIC EVENT. Fanwood celebrates the national bicentennial in 1976 with a picturesque parade on Martine Avenue. This float honors the five New Jersey men who signed the Declaration of Independence.

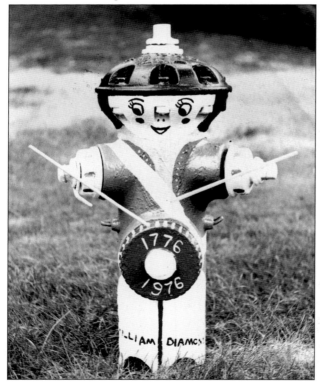

FAME FOR FANWOOD. In celebrating the national bicentennial, Fanwood received national media attention for the unique idea of having its residents paint fire hydrants into caricatures of famous patriots of the Revolutionary War period.

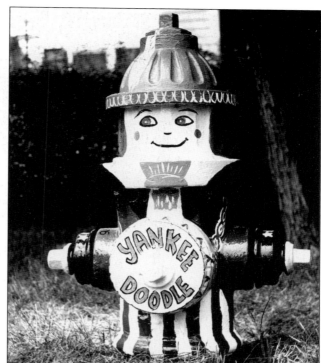

PATRIOTS' FACES. Yankee Doodle, William Diamond (a drummer boy during the Revolution), and Paul Revere are representative renditions of the artistry and imagination of Fanwood citizens of all ages who transformed the fire hydrants into a parade of patriots.

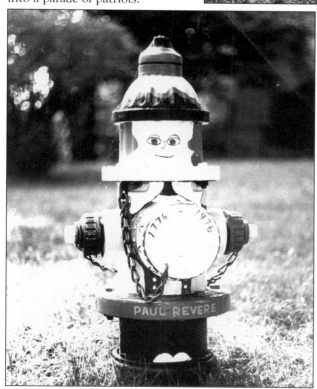

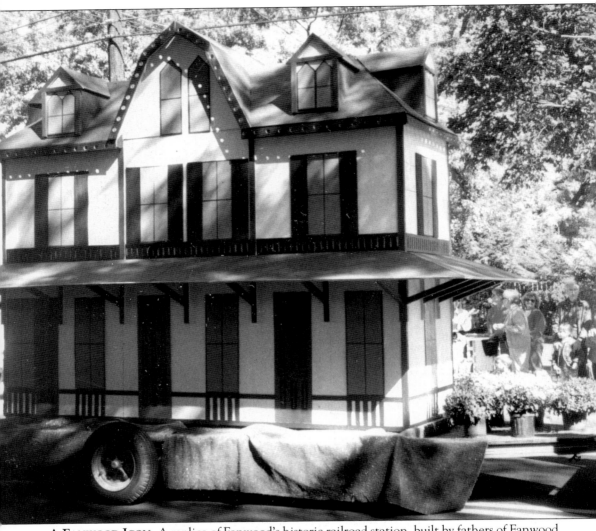

A Fanwood Icon. A replica of Fanwood's historic railroad station, built by fathers of Fanwood Indian Guides, a YMCA organization, is a featured entrant in the 1995 centennial parade.

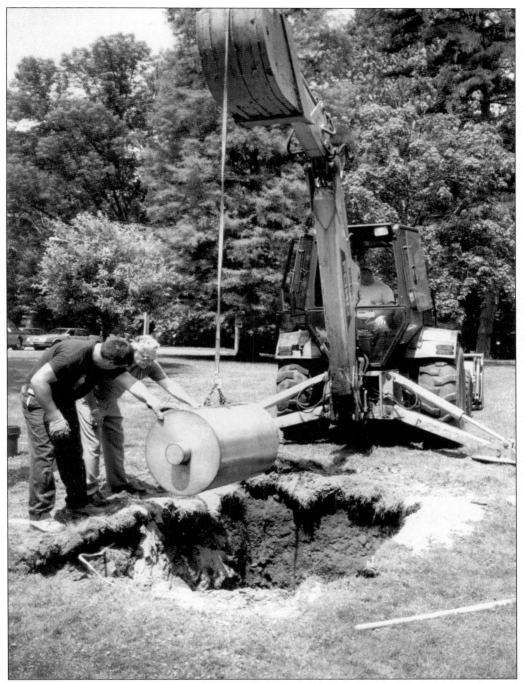

FOR ANOTHER GENERATION. The centennial time capsule is lowered into position in front of borough hall by public works assistant John Piccolla (left) and director Ray Manfra. A bronze and marble marker instructs a future generation to open it in the year 2095. The precise map coordinates of the location are noted in the preserved official minutes of the Fanwood Borough Council.

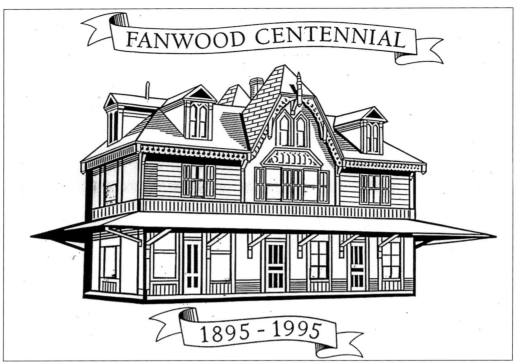

THE HERITAGE SYMBOL. It is only natural that Fanwood's Centennial Celebration Committee selected the old railroad station for its centennial logo. The realignment of the railroad in 1874 and, with it, the construction of the station, were major influences in the creation of the borough.

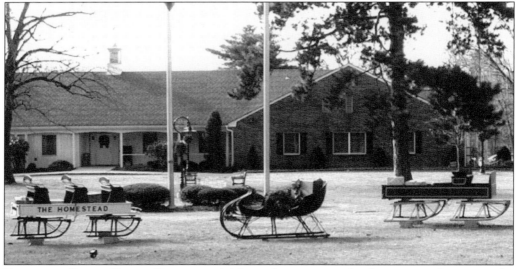

ECHOES OF JINGLE BELLS. Two cargo sleighs and a passenger sleigh appear each year on the grounds in front of borough hall during the December holiday season. Three residents—Carl Eschle, Bob Germinder, and Joe Schott—have restored these sleighs, which once served the Homestead Hotel.

Seven

RURAL LANES
AND STREETSCAPES

Once upon a time, when most of Fanwood was farmland, when few homes lined the rural lanes, when the stretching arms of trees hung over roads and filled meadows, when little commerce had been established, one could walk through a peaceable kingdom, unhurried and serene. These were the first thoroughfares of Fanwood.

Street Map of Fanwood Area in 1882

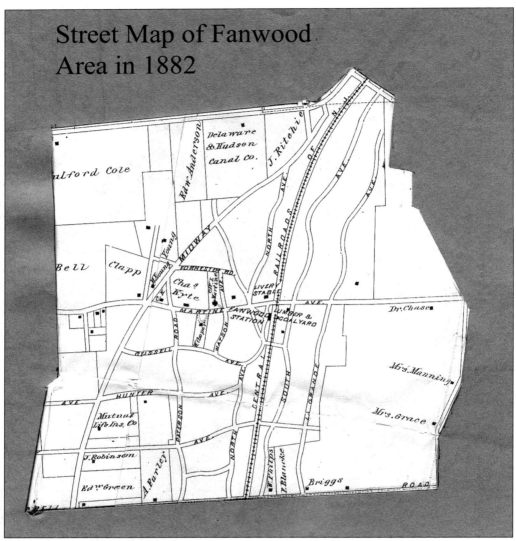

EARLY BYWAYS. This 1882 street map of the area that would become Fanwood in 1895 shows about 30 homes (black squares). The major roads—Martine Avenue, Westfield and Terrill Roads, North and South Avenues, and King Street—are in evidence. Farley and Hunter Avenues and Russell, Paterson, and Watson Roads are in place, but very few homes are built on them.

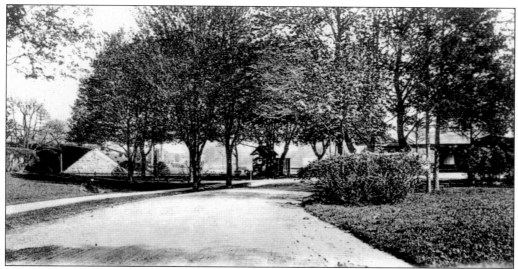

SPACIOUS GROUNDS. The lawns and gardens surrounding the newly occupied north-side railroad station earned the title of Station Park. A wooden truss bridge, with its stone revetments, supported Martine Avenue over the railroad tracks.

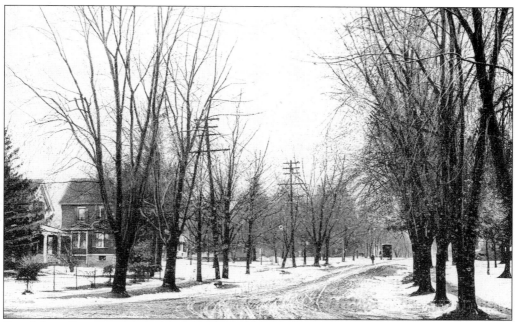

THE MAIN STREET. A carriage makes its way northward on Martine Avenue, likely bringing recently arrived passengers from the railroad station to the Homestead for a weekend away from the heat of the city.

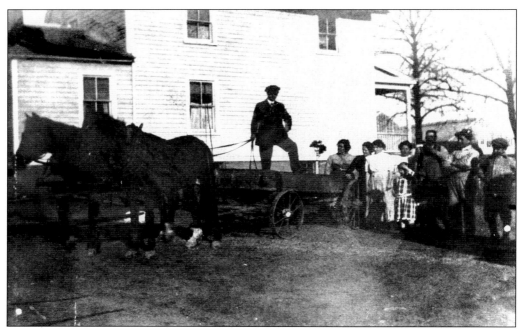

A RURAL SETTING. During the 1890s, the Venezia farm, one of several in Fanwood, was bordered by Terrill Road and Midway Avenue. The horse-drawn wagon was a principle work implement of the farm at that time.

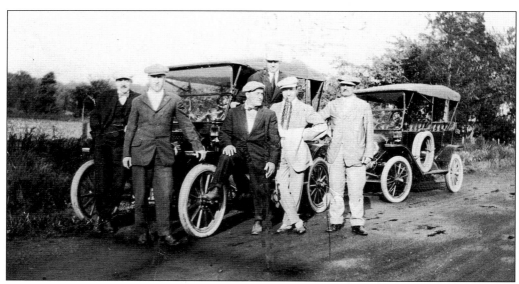

READY TO TOUR. Men assemble around newly purchased automobiles in preparation for a weekend outing on Terrill Road *c.* 1915.

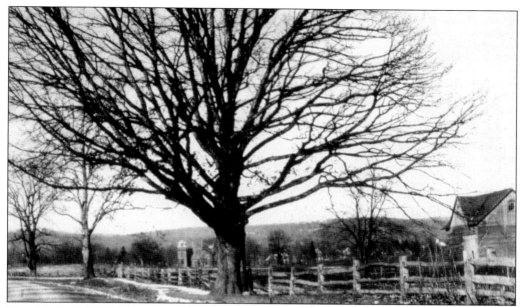

THE MIGHTY OAK. This 1890s photograph of the venerable 300-year-old Fanwood Oak Tree captures a view of All Saints Episcopal Church to the left. The tree to the left of the Fanwood Oak is a sycamore that still stands proudly on Martine Avenue today. The Fanwood Oak succumbed to old age and had to be removed in 1998.

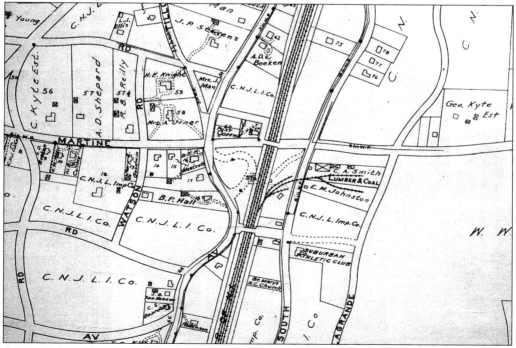

A 1902 MAP. This street map of the geographic center of Fanwood shows the four tracks of the Central Railroad. Mapmakers of this period showed boundary lines, the names of owners, and the shapes of structures, including barns and pathways, on the properties.

A Legend. Heavy snows in the 1930s added grandeur to the Fanwood Oak. More than 100 years ago and on sunnier days, a journalist named Fanny Wood may have sat beneath this tree to write about the beauty of the area. Some of these features were used in railway advertisements to attract people to the country. John Taylor Johnson, president of the Central Railroad of New Jersey, may have named the borough after this legendary lady.

100

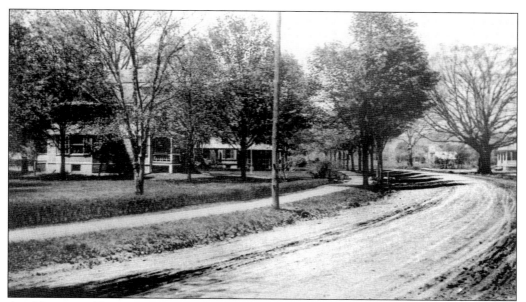

An Unpaved Thoroughfare. This 1910 view, looking north on Martine Avenue from Midway, depicts a dirt-road surface; at that time, there were very few automobiles. The Fanwood Oak makes a stately presence.

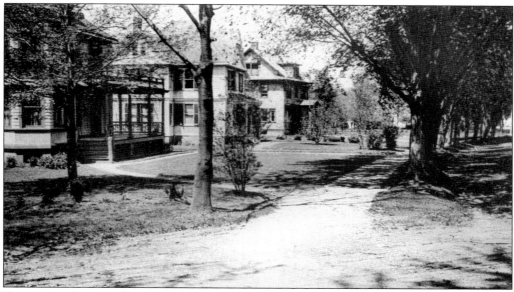

Elegance. Gracious homes and trees lined Martine Avenue north of Paterson Road as the borough entered the 20th century.

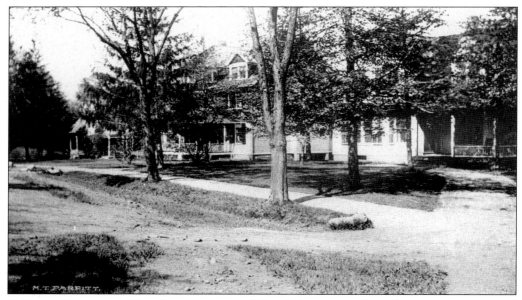

A Prime Location. The close proximity of North Avenue to the railroad station attracted homeowners. Some of the homes were built by the Central New Jersey Land Improvement Company, the real estate arm of the railroad.

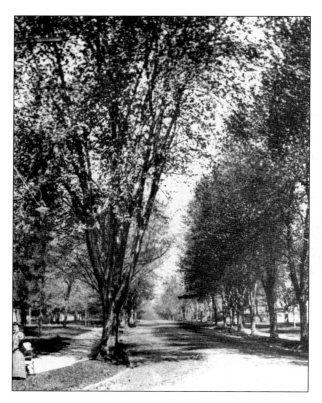

A Serene Setting. This summer scene looks northward on Martine Avenue from the intersection with North Avenue. Trees, well-defined sidewalks, and an unpaved street surface suggest a quiet, unhurried pace of life.

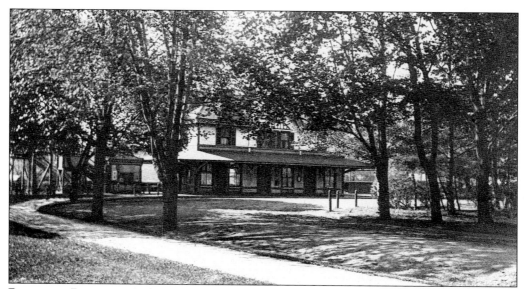

RAILROAD BUILDINGS. The north-side railroad station is sheltered among the trees that line the exit road and the sidewalks. The wooden structure of the pedestrian overpass is evident here, as well as a small building of the kind used for selling newspapers and convenience items.

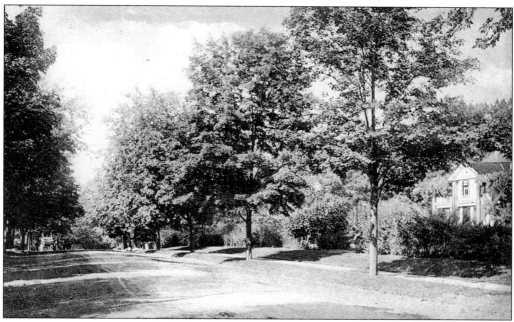

BOROUGH BEAUTIES. This appealing summer scene was captured on film *c.* 1910 on Martine Avenue, looking north from roughly where borough hall stands today. The imposing home of Mayor John Livingston Todd can be seen among the trees and shrubbery.

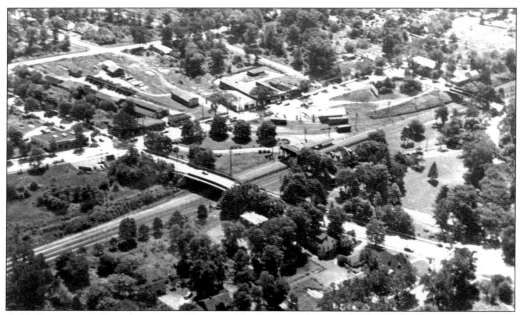

AN OVERHEAD PERSPECTIVE. This aerial photograph, overlooking the Martine Avenue railroad bridge in a southwesterly direction, reveals large lumberyard storage sheds off South Avenue. Beyond are trees where La Grande Park stands today.

A VIEW FROM THE TOP. La Grande Avenue winds past La Grande School to intersect with Martine Avenue, which is lined on both sides with trees. In this 1932 photograph, no stores are in evidence on Martine Avenue in the area between South and La Grande.

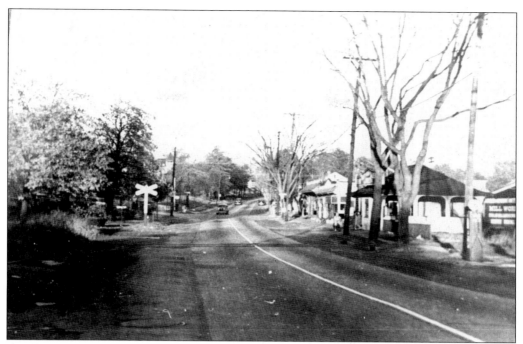

AN EARLY HIGHWAY. This eastward view on South Avenue, Fanwood's main east-west thoroughfare, reveals the sign identifying where the railroad spur crosses the street into the railroad yards.

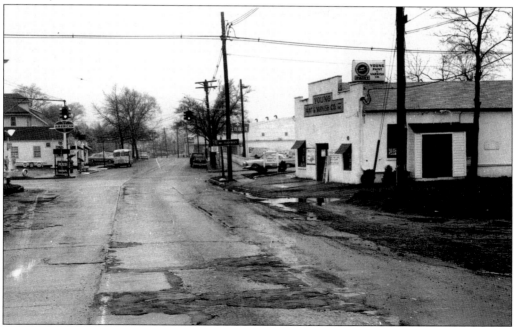

POINTING TO PLAINFIELD. This view on South Avenue, looking west across its intersection with Terrill Road, marks the western boundary of Fanwood. The Young Paint and Varnish Store is on the right.

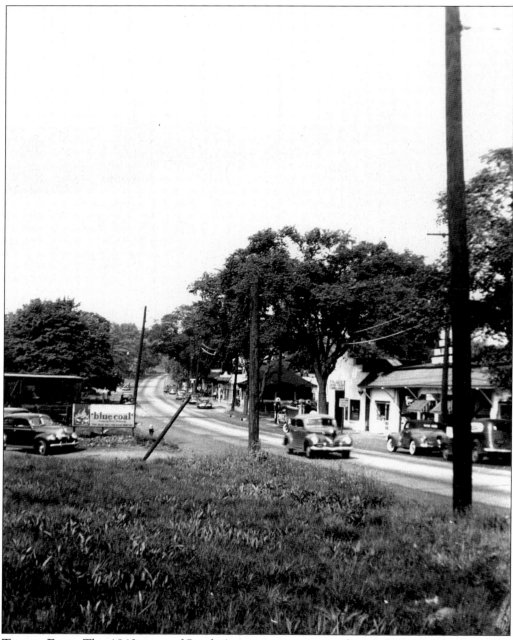

TO THE EAST. This 1940s view of South Avenue points eastward toward Martine Avenue. The sign advertising coal confirms that it fueled most homes in that decade. The curbside gas pumps have long since been replaced by service stations.

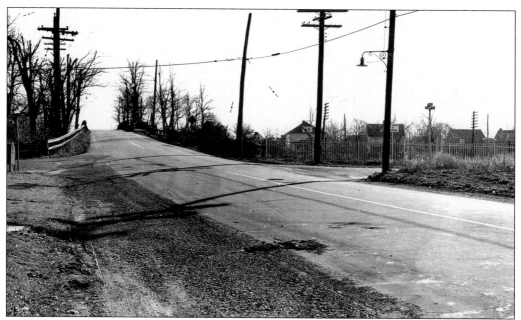

AN EARLY ROADWAY. This southward view on Terrill Road, a passageway that dates back to the Revolutionary War period, shows the narrow bridge over the railroad. North Avenue crosses over from left to the right.

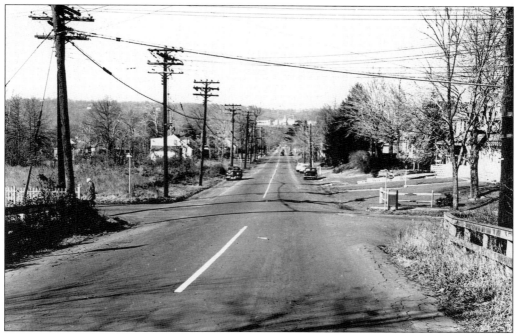

ANOTHER PERSPECTIVE. This view of Terrill Road, pointing north, encompasses a view of Mount St. Mary's Academy perched on the side of the Watchung Mountains.

A BACK-DOOR ANGLE. Taken from the Presbyterian church, this 1950 view looks across La Grande Avenue into the area behind the stores of Martine's west side. The large storage shed of the lumberyard is still present.

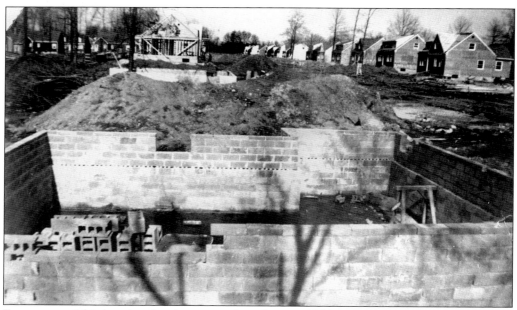

EXPANSION. This housing development taking form in 1953, as seen from the intersection of Clement Place and Shady Lane, was typical of the post–World War II building boom. Fanwood's 1950 census showed 3,228 residents. By 1960, the number had soared to 7,963.

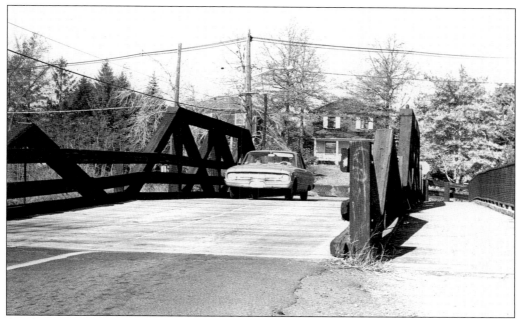

AN OLD PATHWAY. The wooden truss bridge at Sheelen's Crossing permitted passage over the railroad from North and South Avenues. By 1966, it had been replaced by a modern concrete structure.

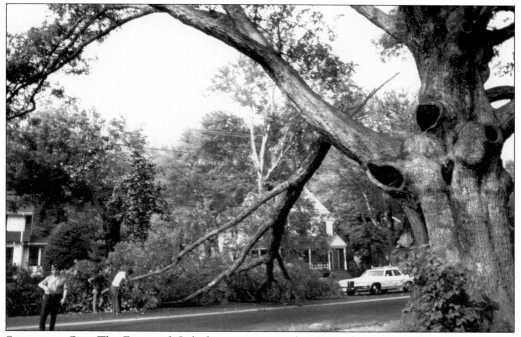

SPLITTING OFF. The Fanwood Oak shows its age in this 1970 photograph. One of its gigantic branches has broken off, obstructing traffic on Martine Avenue.

A REPLACEMENT. The new borough hall was erected in 1979 on North Martine Avenue on the site of the former Homestead Hotel.

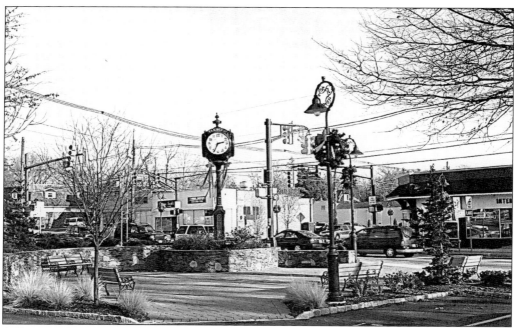

A RECENT ADDITION. The Millennium Clock and the surrounding plaza were built in the year 2000 at the intersection of South and Martine Avenues and were financed by private donations and through the initiative of Mayor Maryanne Connelly. Note the replica of the original bishop's crook street lamp. Almost 100 of these lamps have been placed throughout the borough through the efforts of Clayton Pierce.

Eight
CLUBS FORMED, VOLUNTEERS SERVED

Leisure time brought people together in groups of common interest, while the needs of others were met by volunteers. Both led to the development of clubs of every variety—women's and men's groups, community theater, service clubs, scouting—that have served Fanwood's spirited and giving citizens. Clubs in action are bits of the borough's history.

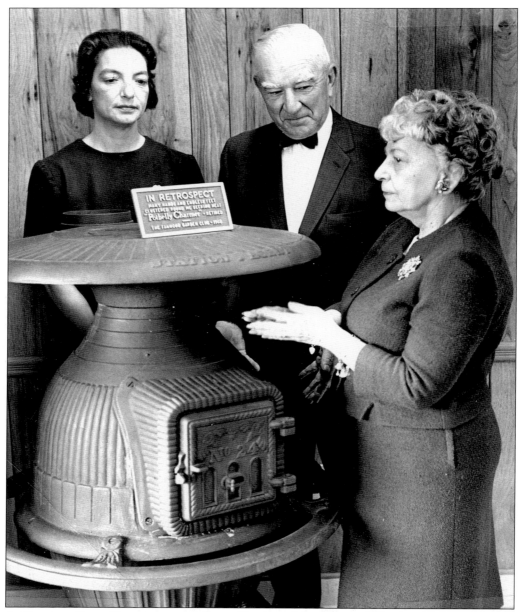

A GARDEN CLUB PRESENTATION. Peggy Dowley of the Fanwood Garden Club pretends to warm her hands over the original potbelly stove from the first railroad station. Eleanor Cruse and Justin Agnoli share in the presentation of a plaque from the club to the Community House, where the stove remains as a part of the building's past. The plaque reads, "In Retrospect— Many hands and endless feet cluster 'round me seeking heat."

MADAM PRESIDENT. As the first president of the Fanwood Community Garden Club, Mrs. Stephen Van Hoesen worked for the preservation of the "Old Oak" on Martine Avenue. In addition, thanks to her, a live tree was planted in 1926 on the grounds of the railroad station. She was responsible for the tradition of decorating a Christmas tree at the station.

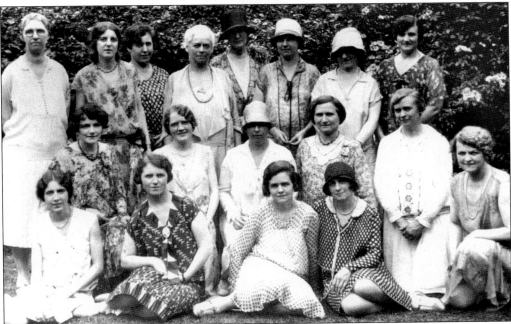

THE GARDEN CLUB. These women were some of the first members of the Fanwood Community Garden Club, formed in 1927. They are, from left to right, as follows: (first row) Mrs. Palmer, Mrs. Vimlehn, Mrs. Green, and Mrs. Maine; (second row) Mrs. Donnelly, Mrs. L. Child, Mrs. Lott, Mrs. Longwitz, Mrs. White, and Mrs. Brown; (third row) Mrs. Van Hoesen, Mrs. Child, Mrs. Harris, Mrs. Frank, Mrs. Tuzo, Mrs. Sayward, Mrs. Huston, and Mrs. Gabler.

A FIELD TRIP. The Fanwood Women's Club visits the Ciba plant during the days of proper hats and gloves and no slacks.

LIGHTING THE WAY. Kiwanis Club members have been successful for more than 40 years in selling luminarias at Christmas time. The proceeds from these sales go to scholarships and other charitable needs. Here, several Kiwanis members from Westfield and Fanwood prepare to sell luminarias. Pictured from left to right are the following: (first row) Ray Napolitano and Charles Jackson; (second row) Bob Brennan, Janet Napolitano, Bill Lehman, and Rev. John Neilson, president.

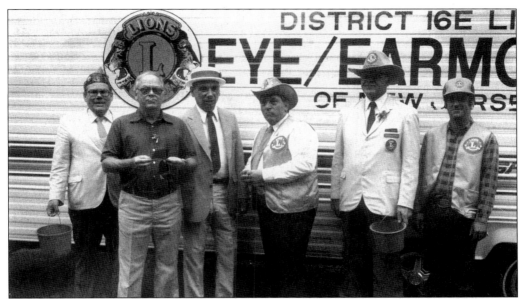

EYE AND EAR TESTS. One of the most important functions of the Lions Club of Fanwood is to hold an eye-ear test in a mobile facility, sponsored by the Eye-Ear Foundation of New Jersey. Volunteers for the event in 1983 are, from left to right, Duane Linden, William Kirner, Robert Germinder, Norman Bonde, Chester Lindsey, and an unidentified member. The club was founded in 1949.

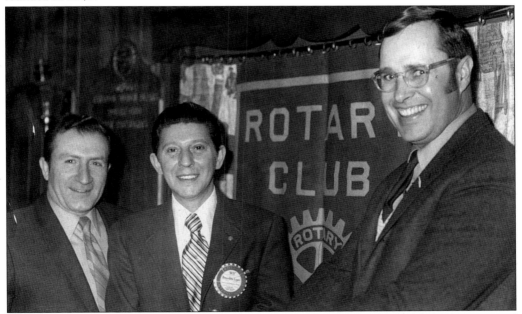

THE ROTARY CLUB. Joseph Qutub, president Ben Lopez, and Ted Frankenbach are proud members of this businessmen's organization, founded in Fanwood and Scotch Plains in 1937 by then school superintendent Howard Brunner. The Rotary has traditions of raising funds for scholarships, supporting local organizations, and sponsoring international students. Members always participate in the Memorial Day parade.

THE ANNUAL CALENDAR. The College Club of Fanwood–Scotch Plains began in 1933. One of the group's major fund-raisers is a calendar, with the proceeds going toward scholarships. This artistic rendition of the old post office was the cover in 2002.

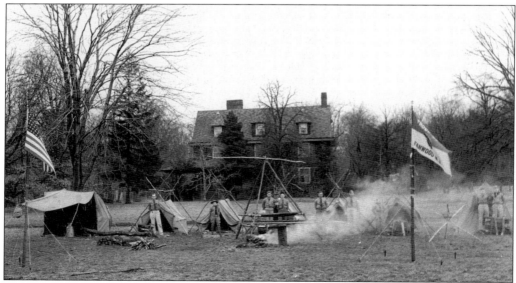

THE GREAT OUTDOORS. Scouting has been an important organization for Fanwood youth for many years. Here, a group of Boy Scouts have set up camp on North Avenue and Forest Road in 1946 at the site of today's library.

PHILATHALIANS, INC.

Present

"Mr. Pim Passes By"

by A. A. MILNE

Fri. & Sat., November 14th - 15th
- Curtain at 8:30 -

SCOTCH PLAINS JUNIOR SCHOOL
PARK AVENUE, SCOTCH PLAINS

Adults $1.25 Students 75c

SHOWTIME. An evening at a Philathalian performance meant a treat in theater pleasure. The group usually produced three plays a year. From 1966 until 1993, the Philathalian awarded a scholarship to a student planning to enter the arts. At one point, these scholarships were funded by members who volunteered at the recycling center.

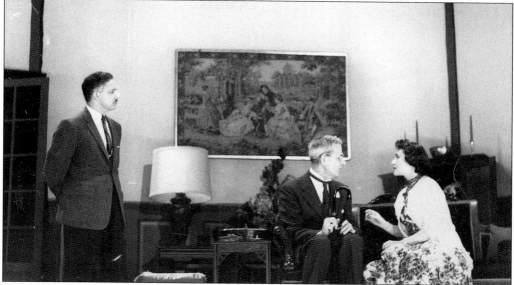

THE PHILATHALIANS PRESENT. Fanwood's community theater for more than 60 years was founded in 1932 by a group of people who wanted to occupy themselves during the Depression. Above is a scene from a 1958 production of *Mr. Pim Passes By*, showing, from left to right, Vince Tobin, Ken Berg, and Manya Ungar. The organization performed in the schools, in the Barn on Elm Avenue, and then in the carriage house on Watson Road until 1998, when the group dissolved.

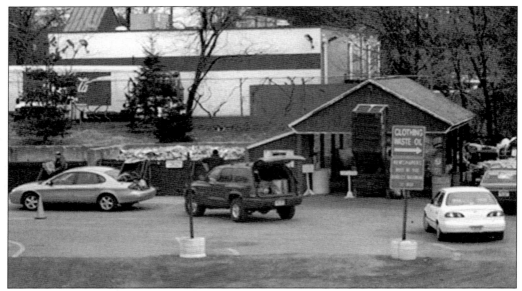

THE RECYCLING CENTER. More than 20 groups work with the recycling center throughout the year. In addition to community groups, other volunteers pitch in with their time. The center recycles newspaper, junk mail, magazines, cardboard, glass, aluminum, tin, plastic, batteries, clothing, oil, and damaged American flags.

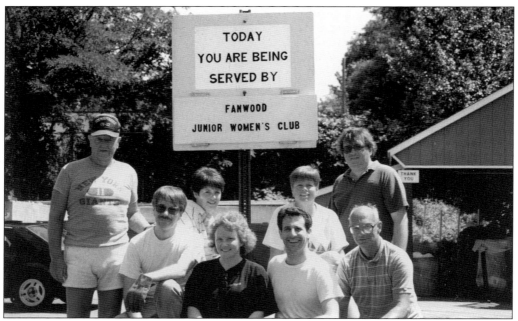

THE RECYCLING ASSOCIATION. In a sense, this is a club of clubs. Representatives from many organizations work with the borough, unloading and sorting materials in exchange for dollars for the groups' treasuries. This unique arrangement has succeeded for more than 20 years. Here, site manager Alan Ebersole directs Fanwood Junior Women's Club members and their spouses on their assignments on a Saturday morning.

Nine

BUSINESSES GIVE VITALITY TO THE COMMUNITY

Commerce and business keep a community alive. Early farmers, shop owners, innkeepers, and salesmen sold farm products, provided residents with the necessities of life, opened hotels and boardinghouses, and peddled their wares. Some stores became social centers as well. These businesses became the forerunners of the restaurants, supermarkets, and light industry of the present. Downtown Fanwood bears different signs and façades now, but the center of commerce is still the crossroads of the community.

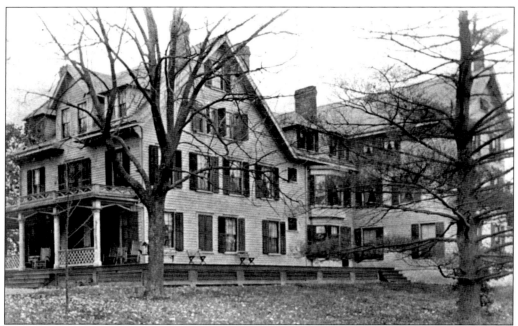

FROM GUESTHOUSE TO RESORT. Realigning the railroad tracks through the "Fanwood Cut" in 1874–1875 brought an increase in visitors to the area. A local guesthouse known as the Russell House gained a reputation as a summer resort for visitors from the city. A rear wing was added and facilities were increased to accommodate as many as 50 guests. The Boucher family acquired the property in 1890, renaming it the Homestead.

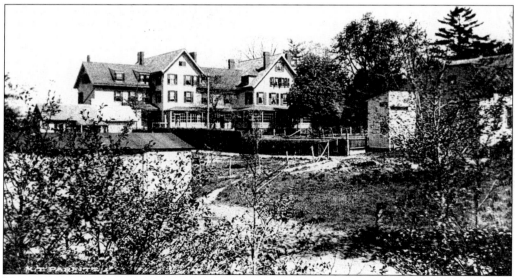

VERANDAS AND LANDSCAPES. Graced with porches and verandas facing Watson Road, the Homestead property also featured five acres of beautifully landscaped grounds and tidy gardens, as well as tennis and croquet courts. A spacious dining room hosted musicales, dances, and other social functions for guests and invited borough residents.

THE SHEELEN BROTHERS' STORE. Standing at the corner of South Avenue and today's Sheelen's Crossing, Fanwood's first grocer and butcher shop was built as a branch of the Baker and Mead Store in Scotch Plains in 1893. Soon acquired by area residents Augustus and Charles Sheelen, the store became a popular meeting place in the new borough. It even served as a courthouse in the early 1900s.

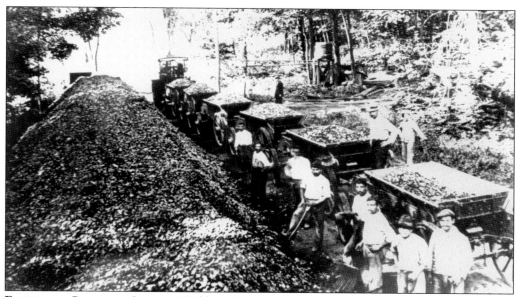

FANWOOD CRUSHED STONE. Weldon Quarry, also known as Fanwood Crushed Stone, employed many local residents in the early 1900s. Area residents can still pass it on Diamond Hill Road in Scotch Plains, where the Weldon family has operated the business continuously since 1900.

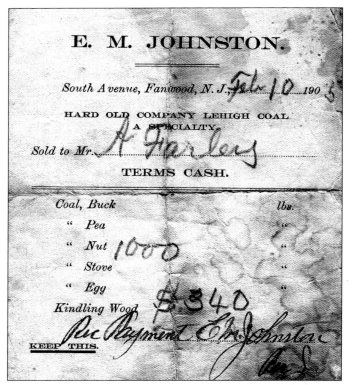

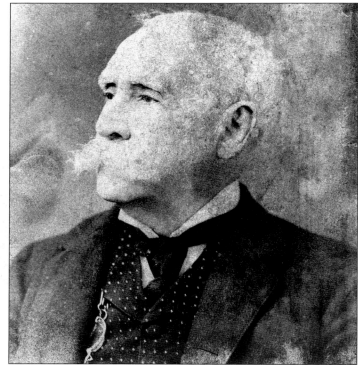

TERMS CASH. The delivery of 1,000 pounds of nut coal to Anthony Farley was paid for in cash, according to this 1905 invoice. Note that the South Avenue address lacks a street number. Mail delivery to houses and businesses in Fanwood would not begin until the early 1930s.

ANTHONY FARLEY. His residence at 140 Farley Avenue was built just before the Civil War. He lived in the home until at least 1905, as the coal invoice attests.

THE FANWOOD CIDER MILL. Fanwood residents could watch their apples being pressed into cider at this local mill, owned by the Phillips family and located adjacent to School Four at 291 La Grande Avenue. Nothing was wasted; the leftover pulp was fed to pigs at area farms.

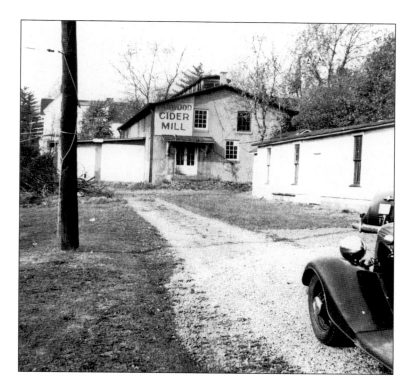

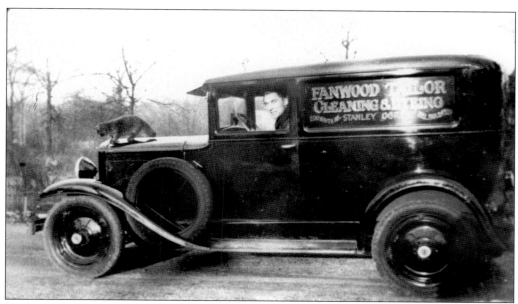

FANWOOD'S TAILOR. This panel truck made pickups and deliveries to the area's well-dressed. This was just one of the many small South Avenue businesses that served residents in the 1930s.

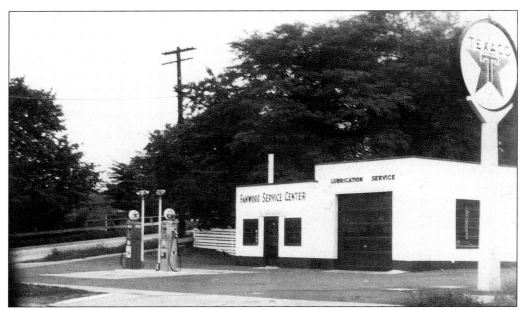

AT THE CROSSROADS. This photograph of the Texaco station at the corner of Martine and South Avenues dates from the 1930s. At the site of today's Dunkin' Donuts, the gas station remained a corner landmark until it was replaced by Sip-N-Dunk Donuts, Fanwood's first all-night café, *c.* 1970.

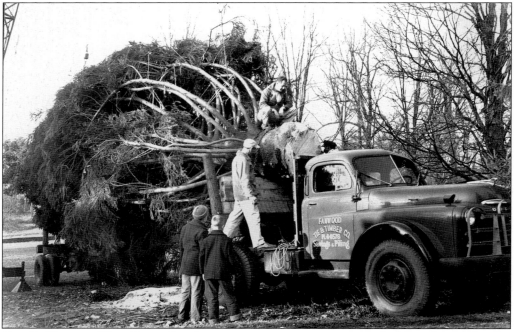

TIE & TIMBER. This Green Brook pine tree is on its way to Rockefeller Center for the Christmas season through the efforts of Fanwood Tie & Timber. The company's sawmill occupied the site of the current A&P supermarket on South Avenue.

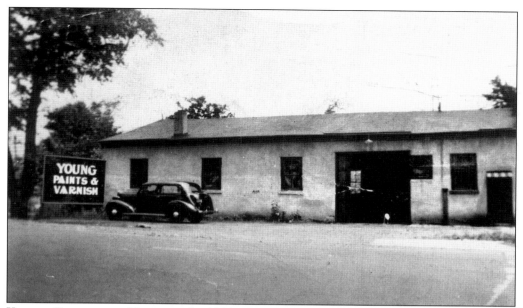

YOUNG PAINT AND VARNISH. In 1929, George Young began this business near the old Samoset Laundry on North Avenue in Plainfield. Moving to the corner of South Avenue and Terrill Road in the 1940s, the concern, through the guidance of four generations of the Young and Andrews families, has expanded to serve both professionals and homeowners.

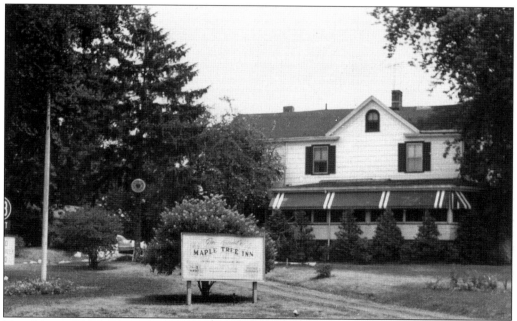

THE MAPLE TREE INN. Throughout the 1940s, 1950s, and 1960s, this inn, owned by Gene Laurent, with its sloping lawn and tree-filled grounds, was a popular dining and political gathering place. The inn faced onto South Avenue at the corner of Terrill Road, on the site now occupied by the Exxon service center.

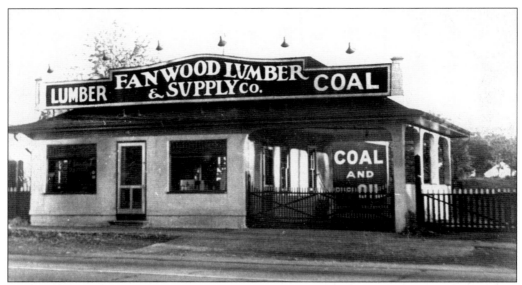

FANWOOD LUMBER AND SUPPLY. Known in its earliest days as the Hand Lumber and Coal Company, this South Avenue enterprise was operated by the Hand family through the late 1960s. Because the company was a valued customer of the Central Railroad of New Jersey, the railroad ran a dedicated spur across South Avenue just west of this building into the lumberyard.

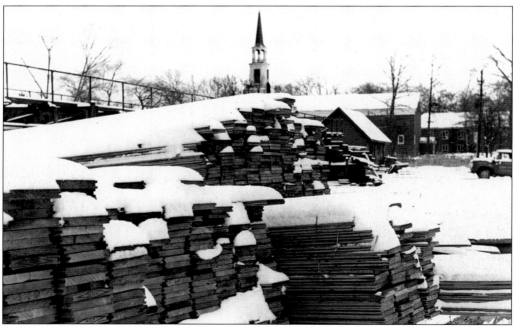

THE LUMBERYARDS. By the late 1950s, expansive lumber sheds and additional retail space for Fanwood Lumber filled much of the block between Martine Avenue and Second Street. The company provided the materials for many of the homes built in Fanwood. In this post-1958 photograph, the steeple on the recently completed Presbyterian church appears in the background. Notice too the elevated railroad trestle that carried coal into the yard.

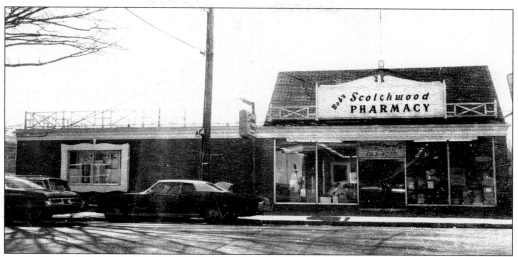

BOB'S PHARMACY, IRMA'S BAG. Entering the South Avenue scene in the 1960s, Scotchwood Pharmacy filled prescriptions and provided convenience for shoppers in search of health and beauty supplies. The low-roofed section of the building housed the original Irma's Bag, before that store moved into its present location in the old IGA supermarket across the street.

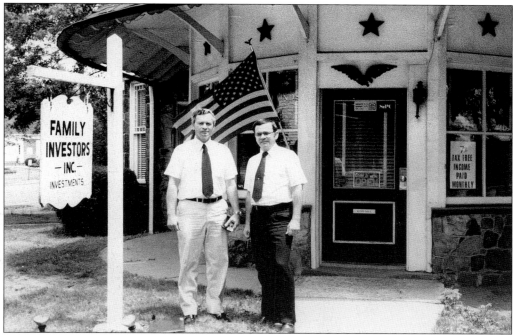

FAMILY INVESTORS. Fred Chemidlin (left) began this business in 1960 in the old post-office building at 266 Martine Avenue. With the early slogan of "Wall Street in Fanwood," the expanding business attracted additional financial advisers and moved twice, settling into its current location next to Scotchwood Florist in the mid-1990s. The firm is now headed by Peter Chemidlin, and 90 percent of its business comes from referrals.

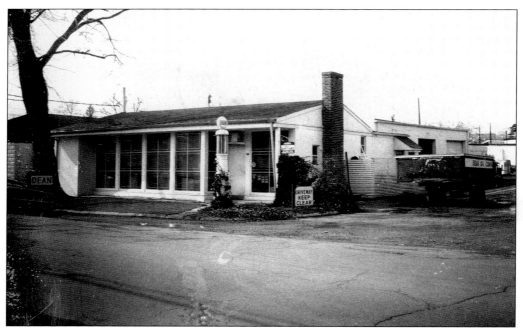

DEAN OIL. In the same block as the lumberyards, but facing onto La Grande Avenue, the Dean Oil Company provided home heating oil to houses in the vicinity, as well as auto parts and supplies.

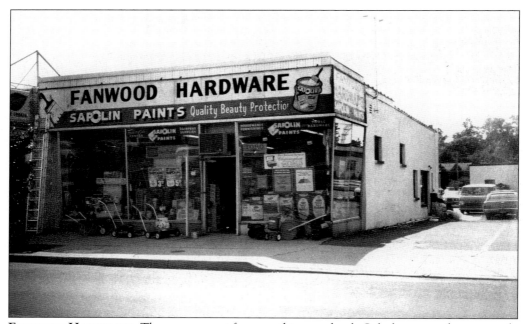

FANWOOD HARDWARE. There was a spot for everything, and only Sol, the owner, knew exactly where to look in this Martine Avenue landmark, where Fanwood families could get supplies for do-it-yourself home and garden projects. A bagel shop fills this location today.